IMAGES
of America

THE CINCINNATI ZOO
AND BOTANICAL GARDEN

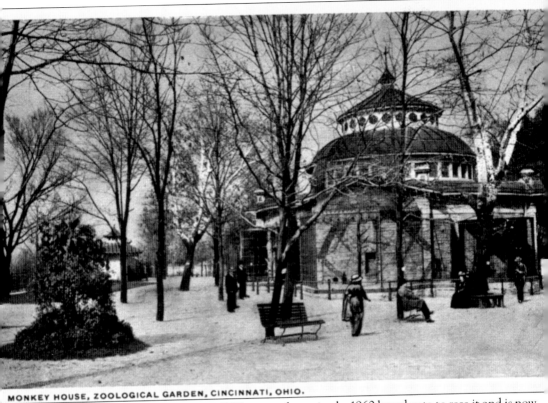

MONKEY HOUSE, ZOOLOGICAL GARDEN, CINCINNATI, OHIO.

Today's Reptile House, shown in a 1905 postcard, survived a 1960 board vote to raze it and is now the oldest existing American zoo building. Built in 1875 as a monkey house, the stone structure had elaborate iron cages outside and a 40-foot-high ceiling. A 1922 remodel included a hospital and was christened by a zoo opera performer "solemnly breaking a bag of peanuts on the doors," according to newspapers. (Courtesy of the Cincinnati Zoo and Botanical Garden.)

ON THE COVER: Asian elephant Hatnee was an early zoo favorite, most often found giving rides under the watchful eye of longtime keeper Ed Coyne, at right. In 1900, about the time of this photograph, Hatnee was 28 years old. She died, according to a 1915 *American Magazine* article, when "one day she suddenly threw up her trunk, trumpeted and fell dead of heart failure." (Courtesy of the Cincinnati Museum Center–Cincinnati Historical Society Library.)

IMAGES
of America

THE CINCINNATI ZOO
AND BOTANICAL GARDEN

Joy W. Kraft

ARCADIA
PUBLISHING

Copyright © 2010 by Joy W. Kraft
ISBN 978-0-7385-7782-1

Published by Arcadia Publishing
Charleston, South Carolina

Printed in the United States of America

Library of Congress Control Number: 2009931252

For all general information contact Arcadia Publishing at:
Telephone 843-853-2070
Fax 843-853-0044
E-mail sales@arcadiapublishing.com
For customer service and orders:
Toll-Free 1-888-313-2665

Visit us on the Internet at www.arcadiapublishing.com

To the plant- and animal-loving employees and volunteers who make the Cincinnati Zoo and Botanical Garden an exquisitely beautiful spot to appreciate nature's beasts and blooms

CONTENTS

FOREWORD

The Cincinnati Zoo and Botanical Garden is one of the leading zoos in the world, thanks to our long history of sticking with what works. Ever since Andrew Erkenbrecher and his cohort of Victorian naturalists founded the Cincinnati Zoological Garden over 137 years ago, we have been known for our unique and varied collection of animals, our botanical gardens, and the role we play as a cultural gathering place for Cincinnatians.

That was the case in the 19th century, when visitors came to the zoo by horse-drawn cart, and throughout the decades since. I still frequently meet people who remember coming to the Cincinnati Summer Opera, outdoors at the zoo from 1920 until the 1970s, as well as those who can name famous animals from days gone by, including Martha, the world's last passenger pigeon; Susie, the gorilla; Angel, the cheetah; and King Tut, the silverback gorilla.

Of course, much has changed over the years. Today zoos play an integral role in science education, and the Cincinnati Zoo and Botanical Garden is proud to have the largest commitment to public education of any zoo. Our 33,000-square-foot Harold C. Schott Education Center is a one-of-a-kind facility, home to 13 classrooms, a full-time public high school called the Zoo Academy, and a three-story greenhouse, the P&G Discovery Forest, filled with New World animals and plants.

And in our fast shrinking wild world, modern zoos play a growing role in wildlife conservation. The Cincinnati Zoo's CREW program, the Center for Conservation and Research of Endangered Wildlife, has experts working around the world with the Sumatran and Indian rhinoceros, endangered small cats, and even endangered plant species.

But thankfully, some things never change, because our motto today, "More animals, more fun," is a reflection of our commitment to live up to our vision to "inspire every visitor with wildlife every day." We have been earning our stripes doing just that every day for nearly 150 years.

I am happy to report that hope remains alive for wildlife and wild places here in the 21st century.

—Thane Maynard
Executive Director

ACKNOWLEDGMENTS

Forget Superman. Marlin Perkins and Jacques Cousteau were my childhood heroes, so they get the credit for planting the seeds of interest for understanding and observing creatures that roam the land and seas, especially those with threatened futures. And what a stroke of luck to settle in a town with a zoo that spotlights my two great loves, animals and plants. As I am a bit of a local history buff, an Arcadia Publishing visual history seemed custom-made for this historic spot that has such a rich, and sometimes tumultuous, past.

At the front of the thank-you line are Thane Maynard, executive director of the zoo; Chad Yelton, director of marketing and public relations; Mike Dulaney, curator of mammals, whose many years at the zoo make him the on-site expert on the animals and their history; and Deb Zureick of the horticulture department, the zoo's keeper of memorabilia. Her jam-packed file cabinets are a gold mine, an informal repository of fascinating facts, photographs, lost tales, and memories of the zoo. Deb is the keeper of scrapbooks, postcards, clippings, letters, and mementoes mailed in by the zoo's many fans.

Melissa Basilone, senior acquisitions editor at Arcadia Publishing, has been an enthusiastic and patient guide through the publication steps, so very different from the daily newspaper world to which I am accustomed. Linda Bailey of the Cincinnati Historical Society was a great help, allowing me to raid its files for hard-to-find photographs. And Diane Mallstrom of the Public Library of Cincinnati and Hamilton County hunted down one of the few remaining images of zoo founder Andrew Erkenbrecher.

And thanks to my husband, Bob, who ever so patiently listens to countless animal stories that are fascinating to only one of us.

Unless noted otherwise, all images appear courtesy of the Cincinnati Zoo and Botanical Garden.

INTRODUCTION

What makes the Cincinnati Zoo and Botanical Garden so special? Is it the impressive number of endangered animals, its one-of-a-kind high school, or the cutting-edge breeding programs? Or is it the fact that it was home to the last passenger pigeon and last Carolina parakeet on earth, or that the world's "only trained gorilla" lived here, or that it had the only summer outdoor zoo opera?

The answer is "all of the above," plus more, which this visual history explores. There are larger zoos today with national and international draws, fatter budgets, bigger tourist markets, and sunnier climes. But their goal is not necessarily to be a part of the community. Our zoo's goal is just that. From the opening days when "visitors took their beer like true American citizens," according to the *Cincinnati Commercial* newspaper, the zoo has been front and center, entertaining, educating, making life more meaningful for Greater Cincinnatians.

Highlighted here are the touchstones, the struggles, the people, and the animals that endured through the years to make this a cornerstone of the area—and the reason that over a million people stream through the gates each year.

Folks may not be traveling cross-country to visit our zoo, especially in our gray winter. But there is a full-time public high school on the grounds, overnight slumber parties, special school admissions, early bird and evening night hikes, gardening education, concerts, wine and beer tastings, the Festival of Lights, Zoo Blooms, and countless community-based programs.

Even the monetary support is largely local. As the least publicly subsidized zoo in Ohio, its special programs and exhibits are bolstered by local businesses, local philanthropists, and local education facilities. "That's the upside to a community like ours," said executive director Thane Maynard. "People are really invested in their community here and are very, very involved."

"It really was styled after old German zoos and botanical gardens," he said. "It was created to be this, what it still is—this beautiful, lush place for people to come on their time off with their families for fun and relaxation. We are here for this community."

One

THE BEGINNING

Credit the ravenous caterpillar for the zoo's beginning. Though introducing non-native species into the wild is now considered environmentally unwise, Andrew Erkenbrecher and his bird-loving friends formed the Society for the Acclimatization of Birds in the early 1870s to do just that. Yearning for the songbirds of their native Germany and a solution to voracious caterpillars stripping city trees in 1872, they imported hungry birds from Europe, wintered them in an old Burnet Woods building, then released thousands of wagtail, skylark, starling, song thrush, Dutch tit, Hungarian thrush, siskin, and dipper. And though the Cincinnati Society of Natural History in 1884 labeled the move "wrong-headed from a zoological stand-point," the group's can-do attitude was established, and they ramped up efforts to open a zoological garden like those in the fatherland.

With brisk German efficiency, a joint stock company was formed by July 11, 1873, offering 6,000 shares at $50 each for the incorporated Zoological Society of Cincinnati.

Eden Park and Burnet Woods were passed up as sites, the former for its lack of large trees and the latter when the mayor vetoed city council's approval, unwilling to sign away city land for such a risky, private venture. Blakely Woods, described as "more remote from the city than could have been wished," was a cow pasture with a few large beech trees, ravines, and springs owned by William and George Wilshire and Augustus Winslow. A 99-year lease was struck on September 25, 1874, for 66.4 acres.

Though buildings were unfinished and many animals were still en route, the Cincinnati Zoological Garden's gates opened on an unseasonably chilly September 18, 1875, and Cincinnati became the second U.S. city to have a zoo garden, trailing Philadelphia by 14 months.

So began what executive director Thane Maynard called *The Perils of Pauline* economic struggles," dotted by market depressions, wars, bankruptcy, and the frustrations of turning a profit. Time and again, well-heeled Cincinnatians, including Albert Fischer, John Hauck, Mary Emery, and Anna Sinton Taft, came to the economic rescue. Finally the City of Cincinnati purchased the assets in 1932 and handed responsibility to the park board and, in turn, to the zoo.

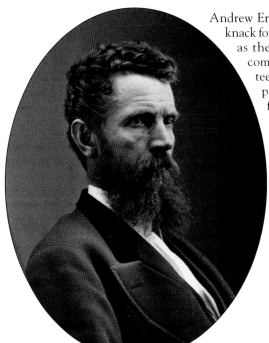

Andrew Erkenbrecher had a weakness for birds and a knack for business. The zoo's founder was better known as the president of Cincinnati's first telephone company by 1874. He came to Cincinnati as a teenager from Heilegersdorf, Germany, with his parents and opened a grain mill and starch factory at age 22. He went on to hold many patents related to his business in St. Bernard and was well respected at the worldwide "expositions" of the day. (Courtesy of the collection of the Public Library of Cincinnati and Hamilton County.)

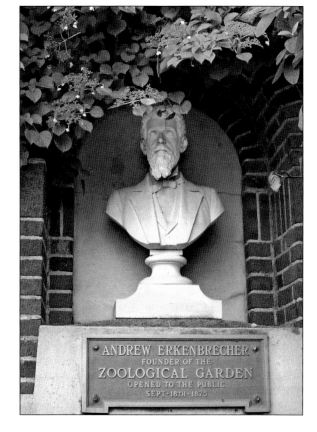

A bust of Erkenbrecher, who died at 63 in 1885, is outside today's Reptile House. His daughter Emma married A. E. Burkhardt, a successful furrier and later zoo president, and one of his sons, Albert Gano, served as zoo treasurer. (Courtesy of the author.)

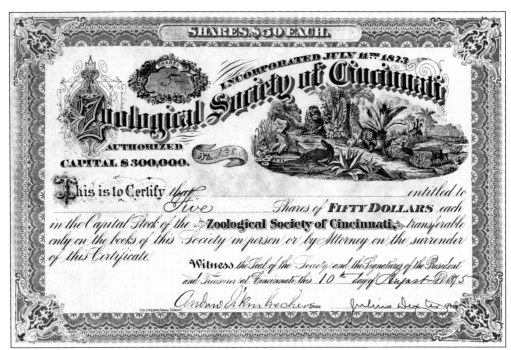

Some 6,000 shares in the Zoological Society of Cincinnati, at $50 each, were authorized in early 1873 to raise $300,000, but after a market crash and recession, only $120,600 had been raised by the end of 1874. Unanticipated start-up costs led to a stockholders' assessment in 1877. A stifling summer in 1881 and an attendance-crimping smallpox outbreak in 1882 spelled "D-E-F-I-C-I-T." By 1885, banks were refusing credit extensions.

Part of the zoo's early emphasis on horticulture is credited to Albert Gano Erkenbrecher, son of the founder and brother-in-law to later zoo president A. E. Burkhardt. He worked in the family starch business and became vice president of A. E. Burkhardt's furriers at 258-260 Race Street. As zoo treasurer, he pushed for a separate botanical garden but settled for blending gardens and lush lawns into existing landscapes and labeling trees as early as the 1890s.

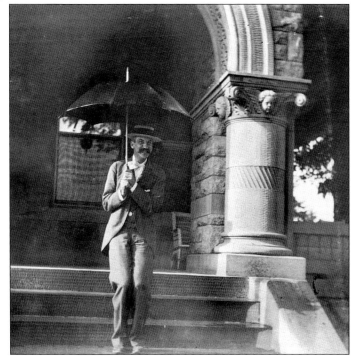

Andrew Erkenbrecher may have been the father of the zoo, but the legendary Sol Stephan, from Dayton, Ohio, was its heart. With an uncanny ability to relate to animals, he showed up for the 1875 opening to keep Conqueror the elephant in line and stayed 62 years, progressing from keeper to curator to director to superintendent and general manager, retiring at 88 in 1937. He lived to be 100.

Stephan, shown below on his daily rounds, was the subject of a regular column in the *Cincinnati Times-Star* and was a natural showman, not above a bit of embellishment and exaggeration if it helped the zoo. During one financial crisis, he pledged employees "five or ten dollars at a time" from his own pocket if they would stay through winter without pay. A donor, impressed by the loyalty, raised $10,000.

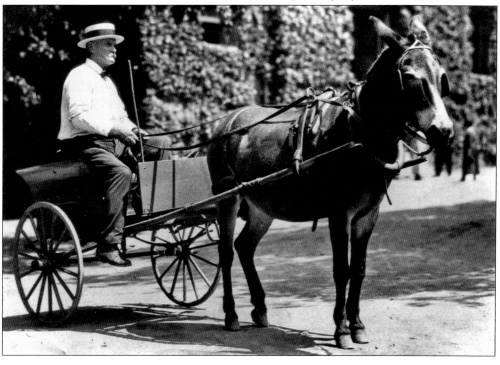

Stephan's philosophy was, "Give the animals the nearest approach possible to their natural condition; feed it as you would your own child; keep its cage clean." He used many unusual animal care approaches, including skipping Monday feedings to keep the big cats hungry and using dogs as wet nurses for cubs or as companions for cubs without litter mates. Setters, large spaniels, and hounds were thought to be best suited for mothering duties.

This July 1875 note from Armin Tenner, corresponding secretary for the Zoological Society of Cincinnati, thanks Julius J. Bantlin, esquire, for a pair of grizzly bears, described by a reporter in a September 19 *Cincinnati Commercial* opening-day story as "two of the finest specimens we ever saw." Private citizens covered the cost of animals or donated from their own collections when the zoo's initial purchasing budget was reduced from $50,000 to $20,000.

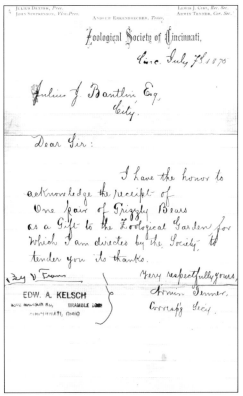

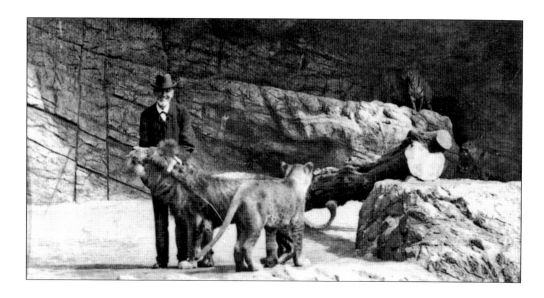

Some early zoo animals were donated by private citizens or groups, while others came from bankrupt circuses or animal shows. But many were purchased from animal dealer and showman Carl Hagenbeck (shown above with the lions) from Stellingen, Germany, near Hamburg. At one time the world's largest animal dealer, he developed a strong business relationship with the zoo, and Sol Stephan became his American representative. Hagenbeck had such confidence in the Cincinnati operation that "it was the only zoo in the country which has a standing order by which Hagenbeck will buy all animals born at the Cincinnati garden," according to a newspaper of the time. He is shown below in the back of the zebra-drawn carriage at the Hagenbeck Thierpark, or zoo, being driven by his son Heinrich, with Joseph Stephan, Sol's son who also worked at the zoo.

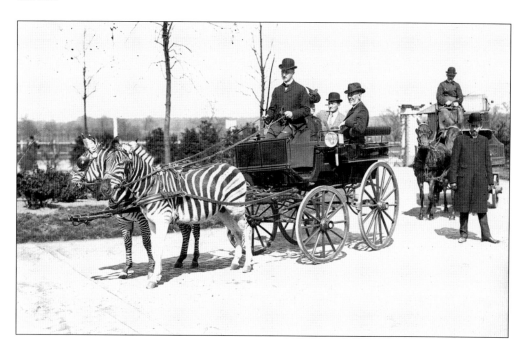

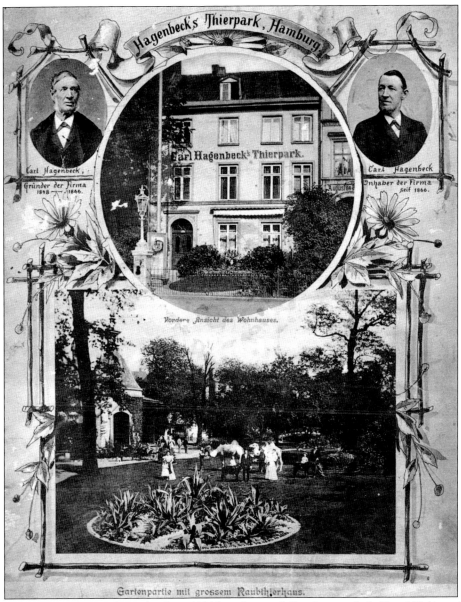

The Hagenbeck Thierpark catalog from 1898 listed animals "packing included" and "delivery free on board to Hoboken, New Jersey." Animals offered included one pair of walruses, "the only pair in captivity," for $7,500; one female hippopotamus, six months, $3,000; one male Senegal lion, "castrated and tame," $450; one female Bengal tiger with "bad teeth and a weak left eye, otherwise large and healthy," $400; one pair Nubian lions, $1,500; one emu half-grown, $75; and two small macaques, $15 each. The luxurious park, known for its barless exhibits, using moats and artificial rocks instead of cages, was internationally renowned, but fell victim to World War I and closed in 1920 for two years when it could not feed the animals or heat the exhibits. It was rebuilt after World War II and is still run by the family. The Hagenbeck and Stephan families were so close that Sol's son Joseph went to Germany to learn about the cageless exhibits and management, and the Hagenbeck sons stayed with the Stephans when the Hagenbeck American Circus "wintered over" at the Carthage fairgrounds.

The State of Ohio,
HAMILTON COUNTY.
} ss.

RECORDER'S ÷ OFFICE.

I, GEO. O. DECKEBACH, *Recorder within and for the County aforesaid, do hereby certify the foregoing to be a true and correct copy.*

of *Lease Wm Wilshire et al "To" The Zoological Society of Cincinnati*

Received, *and recorded on the* Twenty fifth *day of* September 1884, *in Book No.* 51 *page* 57 *Hamilton County, Ohio, Records.*

In Testimony Whereof, *I have hereunto set my hand, and affixed my official seal at Cincinnati, this* 21st *day of* February *A. D. 1881*

Geo O Deckebach
Recorder.

Submitted by

KELSCH REALTY CO.
REAL ESTATE AND NOTARY PUBLIC
6302 MADISON RD.
CINCINNATI 27, OHIO BR 1023

The Zoological Society of Cincinnati lease, dated September 24, 1874, and recorded September 25, for the cow pasture known as Blakely Woods, specified a cash payment of $10,000 with no rent payments for the first two years, then $5,000 for the third through fifth years, $6,000 for the sixth through 10th years, and then $7,500 thereafter, annually, for land in plat book No. 2, pages 258 and 259 of the office of the recorder of Hamilton County. The property, part of which was originally on the Andrew McMillan estate, is described in an annual report as a "tract of land in the southwest corner of Avondale from Carthage Pike consisting of 66.04 acres. The ground is somewhat broken and abrupt from Carthage Pike then becomes nearly level sloping gently to the north whence they command an extensive view. Three ravines run through the land. The most beautiful of these runs along the east line of the property. . . . These grounds are more remote from the city than would have been wished but they are not far from it."

CINCINNATI ZOOLOGICAL SOCIETY.

Receipts and Expenditures, from January 22 to July 31, 1898.

RECEIPTS.		EXPENDITURES.	
Gate, Cash,	$9,845.95	Labor, New Account,	$5,568.42
Excursions, "	859.44	Labor, Old "	4,194.39
Concerts, "	1,625.00	Feed, New "	2,460.74
Schools, "	1,259.35	Taxes, Old " $1,365.72,New, $385.91,	1,751.63
	—$13,589.74	Ground Rent, Old Acct. $1,562.50, Int. $44.00,	1,606.50
Associate Member Tickets,	3,705.00	Repairs,	979.50
Restaurant, Rent and Light,	1,557.60	Expense, Sundry,	433.03
Caroussel,	394.75	Music,	1,485.00
Pony Track,	698.55	Advertising,	419.04
Elephant Track,	90.25	Printing and Stationery,	219.57
Privileges,	232.18	Animals,	67.60
Reserved Seats,	158.79	Light and Repairs to,	199.87
Program,	377.86	Fuel,	250.01
Animals and Hides,	104.30	Keeping Ponies, etc., Old Account,	104.00
Rent of Camel,	50.00	Bills Payable,	6,200.00
Refunded from Pay Roll	139.19	Interest,	65.17
Bills Payable,	6,200.00	Commission Membership Tickets,	182.00
Interest,	20.76	Total Expenditures,	—$26,186.47
Total Receipts,	—$27,618.97	Balance,	$ 1,432.50

On January 21, 1898, the day the Receivers were appointed, the Treasurer's books showed cash on hand $96.43, which was retained by him and charged to his account, thus leaving nothing of either cash or available assets for the Receivers.

The statement made to the Receivers showed the indebtedness of the Society to be, on January 1, 1898:

Bills Payable,	.	.	.	$55,434.65
Accounts Payable,	.	.	.	19,058.45
Employees' Back Pay,	.	.	.	6,521.30
				$81,014.60

Between January 1st and January 22d, the day the Receivers took charge, this amount was increased by ground rent, $1,562.50

Money troubles put the zoo in receivership in January 1898 under Albert Fischer and Gustav Tafel, Cincinnati's mayor. The books showed just $96.43 on hand, with the zoo in the hole $81,014.60. By the end of July, balance was restored, with $1,432.50 after expenditures. The for-profit venture was abandoned, and in 1899, the Cincinnati Zoological Company was organized. Two years later, the Cincinnati Traction Company took control through stock purchases.

One of the earliest guides to the zoo was printed in 1878 by the Krebs Lithograph Company and consisted of artist drawings of zoo scenes. The cover was designed with elaborate drawings of an alligator, leopard, lion, giraffes, elk, and birds surrounded by lush native vegetation, not exactly an accurate description of the early zoo displays.

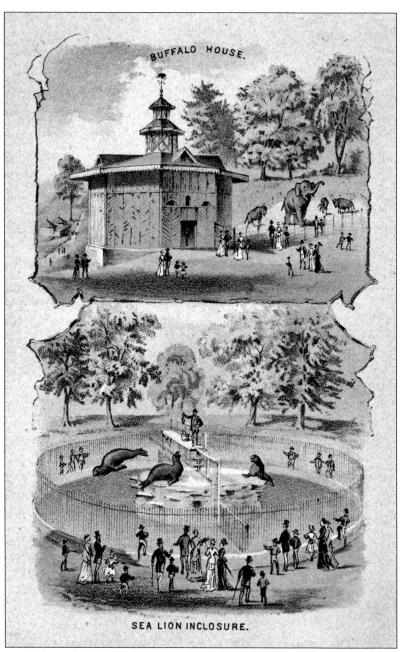

This lithograph from the 1878 Krebs guide shows the Buffalo House, a wooden structure with branches and tree bark attached to the walls, the first building at the zoo and the only one of the large original buildings not designed by architect James McLaughlin. Not surprisingly, it burned down by the beginning of the 20th century. The sea lion exhibit, shown at the bottom, was one of the most popular in the early days and was located behind today's Children's Zoo near the present-day sea lion exhibit. The first sea lion pool, built in 1877, was 60 feet in diameter, with animals costing "nearly a thousand dollars," according to the 1877 annual report. The next year, a baby California sea lion was born at the zoo, believed to be the first conceived and born in captivity, even though it lived for only a few months.

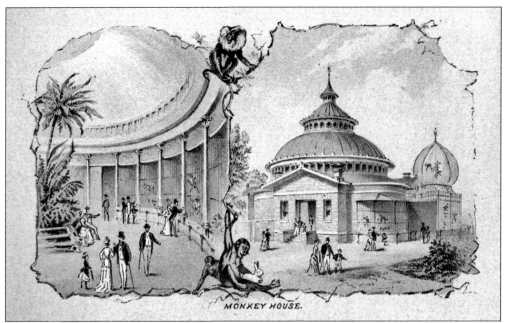

MONKEY HOUSE.

The stone Monkey House (today's Reptile House, now surrounded by lush plantings and trees), above, is the oldest existing American zoo building. Much maligned through the years as being out of date, it has been remodeled several times, surviving a board vote to raze it in the early 1960s. Measuring 60 feet in diameter with rows of dome skylights, it was originally divided into cages along the inside walls with Corinthian columns and three large elaborate iron cages, now gone, on the outside. The cost to build it in 1875 was $14,000. The entry, shown below, was for visitors arriving by carriage, buggy, or horse-drawn trolley. It is described as being the "Washington Avenue" entrance on the east side of the grounds.

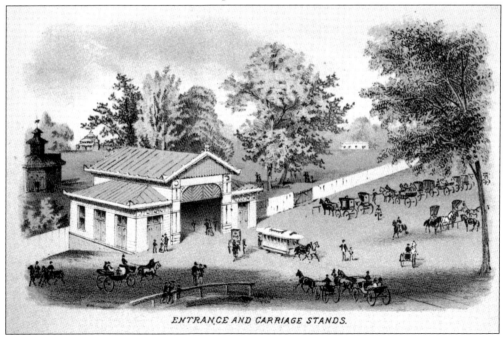

ENTRANCE AND CARRIAGE STANDS.

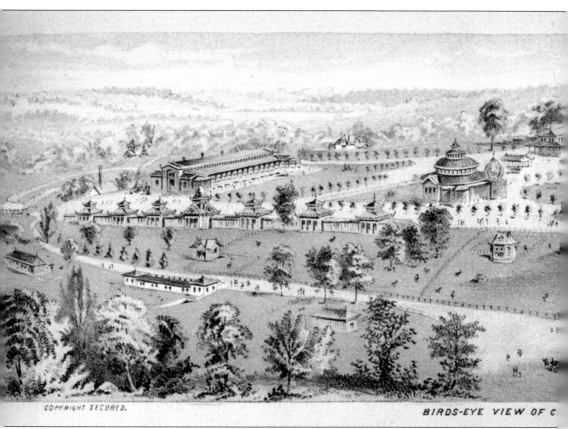

COPYRIGHT SECURED.

BIRDS-EYE VIEW OF C

This bird's-eye view lithograph from the 1878 guide shows the layout of the zoo and the range of varied topography, including creeks and ravines that were landscaped with rocks for natural displays, park-like pastures, level areas for grazing hoofed animals, and steep hillsides to evoke a natural setting for the bears. The view is from today's Vine Street and Erkenbrecher Avenue

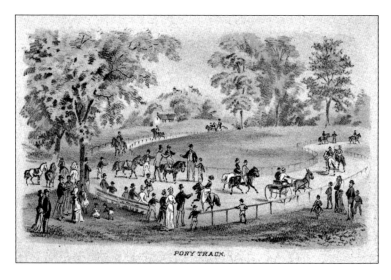

PONY TRACK.

The Pony Track, near today's Safari Camp and Safari Lodge, was one of the most popular spots in the zoo's early years. Built in 1877, it was the site of pony and donkey rides for children and later elephant rides for children and adults. Crowd favorite Lil, one of the most docile elephants to call the zoo home, could often be found here.

20

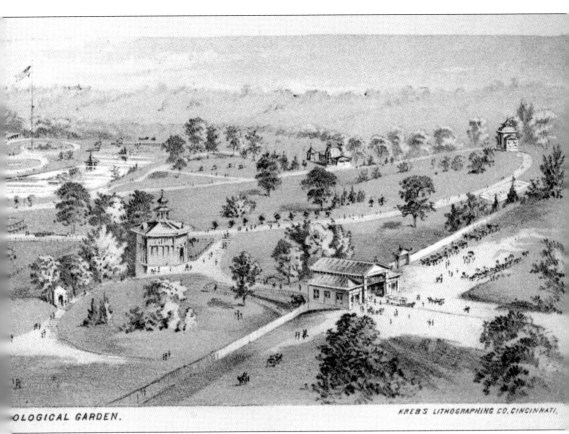

OLOGICAL GARDEN.

KREB'S LITHOGRAPHING CO. CINCINNATI.

looking east. The Monkey House, today's Reptile House, is to the left of center with the Carnivora House to the far left and the original stone Aviaries lined up in a row. Only one of the Aviaries still exists.

The 50-plus animals in the original prairie dog exhibit, near today's Elephant Reserve, produced many offspring in the ensuing years. The *Cincinnati Commercial* described one of the opening-day ostrich specimens, located with the kangaroos, near today's Manatee Springs exhibit, as "boss of the shanty carrying about a perfect bank of Kossuth hat feathers." The Small Carnivora housed foxes, wolves, and small cats.

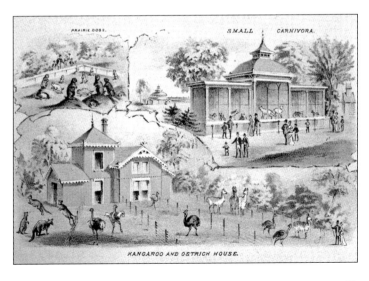

KANGAROO AND OSTRICH HOUSE.

21

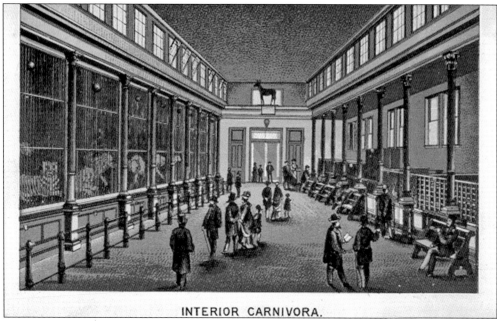

INTERIOR CARNIVORA.

The Carnivora House, largest of the original exhibit buildings, was home to the big cats, with access to adjacent, outside cages. It was also used to display mounted animals, a common practice of the day. Before opening day, a donkey was attacked by an escaped lioness (later killed for the offense). When the donkey eventually died, both were displayed. The donkey can be seen above the entry in the lithograph.

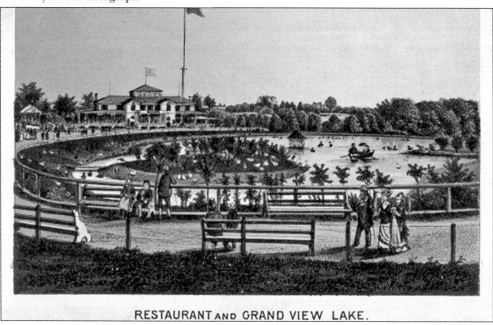

RESTAURANT and GRAND VIEW LAKE.

Fronted by the lake, the Clubhouse and Restaurant building took center stage and was so costly to build, totaling $28,000, that it was not finished until 1876. With space for 1,500 guests, it was the place to be seen, the social center for diners, politicians, music-lovers, and those out for a stroll around the lake. It was built near the south side of today's Children's Zoo, near Gibbon Island.

Two

BRICKS AND MORTAR

From the beginning, the zoo has included a fascinating collection of buildings in architectural styles ranging from Victorian to rustic, Renaissance Revival, Italianate, Japanese, Teutonic, Indo-Islamic, modern, and transitional. Zoo architects, whose works span generations, include James W. McLaughlin, Samuel Hannaford and Sons, Fechheimer and Ihorst, Elzner and Anderson, Kruckemeyer and Strong, Carl A. Strauss, McCollow and Associates, Glaser and Myers and Cornette/Violetta, who designed today's Vine Street Village.

McLaughlin, president of the Cincinnati chapter of the American Institute of Architects from 1878 to 1881, followed the lay of the land tweaked by landscape engineer Theodor Findeisen, who was hired in 1874 to sculpt the grounds following the existing features and to create "vistas of varied beauty" by grading, leveling, and excavating. A circuitous plan that survives today was mapped with an outer path wide enough for carriages and interconnecting walkways.

A successful and popular residential and public building architect, McLaughlin designed part of the Cincinnati Art Museum, the original Shillito's on Seventh Street (now hidden under a later facade), and part of today's McAlpin building on Fourth Street.

The park's exhibits were meant to reflect the housed animals' country of origin. The stone bear pits were carved out of the steepest hillside to mimic caves. And the Deer House, made of log lodge construction with roof thatching, brought to mind their native forests. One newspaper suggested the Camel House would be in the shape of a tent, though that did not happen. The buildings, originally budgeted at $80,000, were to be "arranged to meet the best and most natural comfort of the animals in them," according to the same newspaper, and that was probably true, with the exception of Conqueror the elephant. The African bull tore down the branches and tree bark covering the walls of the Buffalo House. But that was the only building not designed by McLaughlin.

Findeisen and the zoo board had a parting of the ways at the end of 1874, and construction did not begin until the spring of 1875, so it is no surprise that many buildings were unfinished at the September opening.

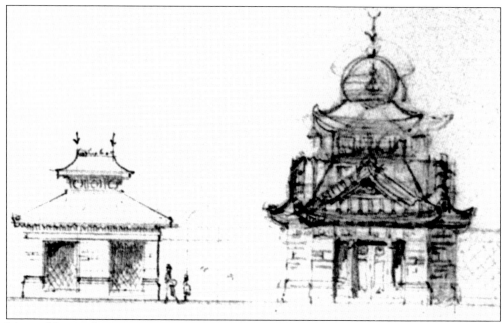

Many of the smaller specimens of the zoo's birds, as well as toucans, pheasants, and macaws, were kept in the Aviaries, seven square stone buildings joined by "summer cages." Each was about 20-by-18 feet with a pagoda-style roof, with the central building originally designed to be 27 feet wide and more elaborate. The cost was $15,000. The sketch shows James McLaughlin's changing ideas for the rooflines. The design is similar to India-style structures at the Berlin animal park of the day. The photograph below, from the dawn of the 20th century, shows the final result. Monkeys moved to the buildings in 1953, and in 1974, six buildings were razed for Gorilla World. The seventh is now across from the Cat House and was dedicated in 1977 to Martha, the last passenger pigeon, and Incas, the last Carolina parakeet.

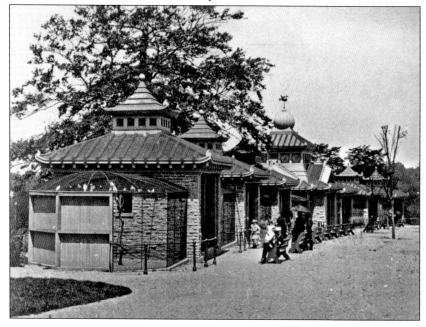

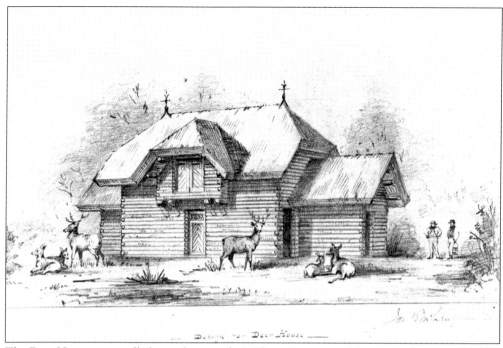

The Deer House, originally located near today's Rhino Reserve and Bongo Yard, was made of log construction with a thatched reed roof that might be found in the forests of the animal's origin. Camels and deer had separate yards in front, and a rustic bridge across the way led down to the popular Pony and Elephant Track.

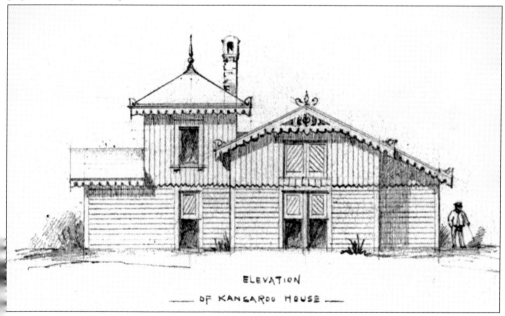

The Kangaroo, Llama, and Ostrich House, originally near today's Manatee Springs, was surrounded by several fenced yards containing rhea, ostrich, emus, llamas, kangaroos, wild boar, yaks, and several deer species. Barn-style doors, wood construction, and scalloped trim could all be found in German zoo designs at the time. The tower's roofline is echoed by today's Vine Street Village roofs.

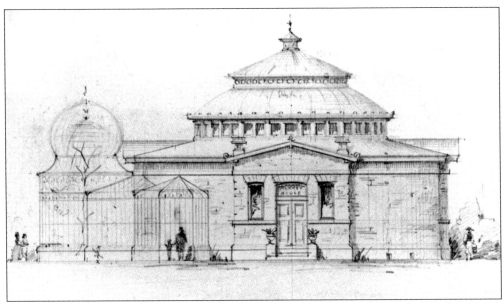

Today's Reptile House, the oldest existing American zoo building, was built as the Monkey House in 1875 and is based on a sketch by architect James McLaughlin that was originally considered for the aviary. The outdoor cage, shown in the sketch, with a Moorish-style top, was almost 30 feet high, quite unusual at the time. Skylights around the central dome, 40- to 45-foot high, provided light for the inside, and perimeter cages were accented by Corinthian columns. The star of the building in 1898 was Blue Nose, a giant Mandrill baboon from Africa touted as the "biggest and best specimen in the country." A hospital facility was added in 1922, the outdoor cages were removed, and a later remodeling included heated floors in the exhibits to accommodate the reptiles that arrived in 1951, about the time the photograph below was taken.

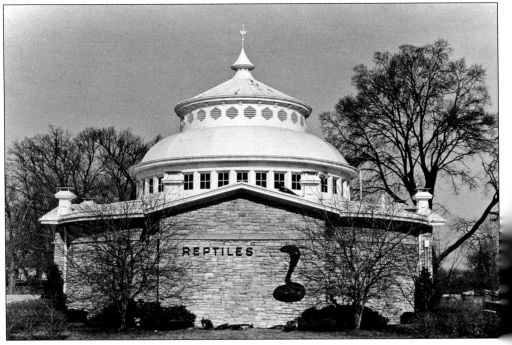

McLaughlin's original sketches, seen above, for the zoo's entry included a small free-standing ticket office with three ticket windows in front, a stove in the center for heat and a porch trimmed with Victorian embellishments. The actual entry pavilion that was built, visible in a photograph below from the 1890s, shows the small office, at left, incorporated into a larger structure that was the drop-off point for carriages, trolleys, and, later, automobiles. Admission was 25¢ for adults and 10¢ for children under 10. The turnstiles and rooflines of today's entry echo the original building.

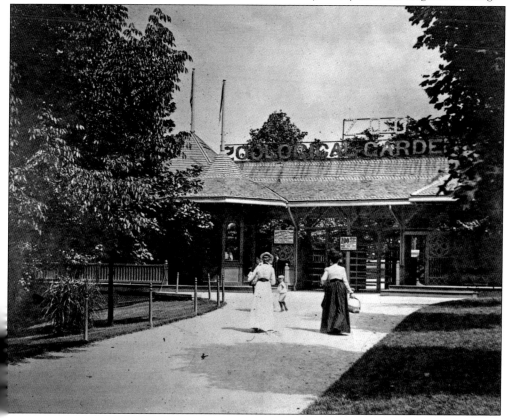

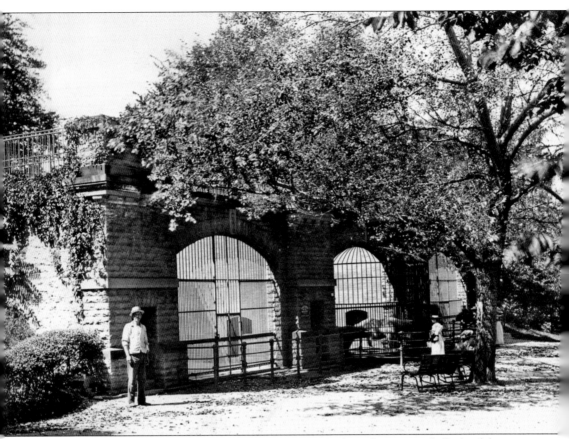

The Bear Pits, a trio of stone and steel bar structures built in the steepest hillside of the property, near the lower end of today's Lords of the Arctic exhibit, housed polar bears in the center section with a bowed cage in front, and grizzly bears, cinnamon bears, or black bears on the sides. The enclosures were considered to be state of the art when the zoo opened but did not provide adequate space for animals accustomed to roaming in wide areas. At one point, according to newspaper reports, a missing bear cub was found, after removing the adult bears from the cage, wedged in a deep foundation crevice covered in mud but still alive. Parts of the Bear Pits' foundation walls could still be seen into the 1980s.

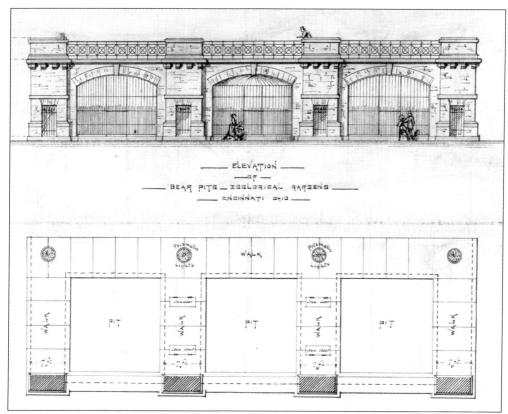

Original drawings, seen above, for the bear pits by architect James McLaughlin show a 78-foot-long stone structure with three 22-by-24-foot side-by-side compartments, each with two 4-by-6-foot dens, small water pools, and a climbing pole in the center. Steps to the side allow visitors to climb up and view the bears from atop the 12-foot-high enclosures. The design, which changed from a pediment accent on each section to an iron rail accent, was based on the 1868 bear pits, in the photograph below, from a Hamburg zoo with an almost-identical design. It was common for poles to be placed in bear exhibits and covered with branches and twigs so the bears could climb up for "treats" and a close-up view by visitors watching from the top.

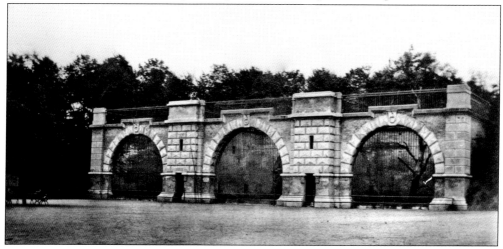

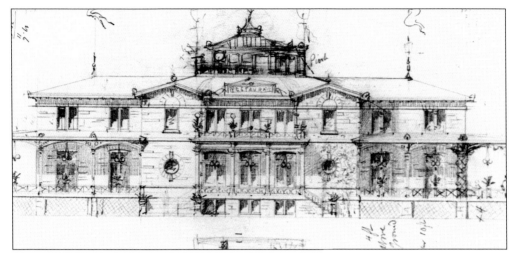

Architect James McLaughlin's elaborate Clubhouse and Restaurant, the zoo's centerpiece and a social gathering spot for movers and shakers of the day, was the largest and most costly of the zoo's public buildings, so expensive that it was not finished until 1876. His drawing, seen above, shows an Italianate structure made of grey limestone with open verandas and a grand staircase. The actual structure, shown below, was toned down and lacked some of the drawing's embellishments, sporting a modified entry minus the second-story center pediment. At the beginning of the 20th century, noted architects Samuel Hannaford and Sons surrounded the original building with a two-story colonnaded veranda that radically changed the style. In the late 1920s, an open-air opera pavilion was added on one side and a band shell on the other. The original section was razed in 1937.

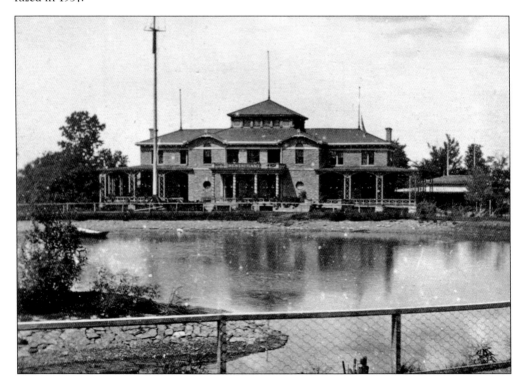

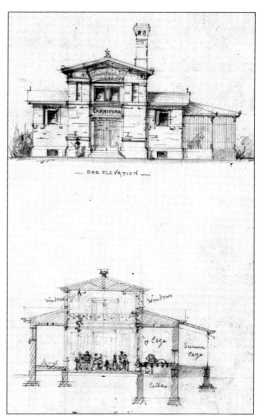

The largest of the original exhibits was the Carnivora House, with 16 indoor cages and 8 outdoor pens. McLaughlin's massive, classical design was built of grey limestone with clerestory windows along its 125-foot length. Heated by steam, it was home to big cats, reptiles, chimpanzees, and other animals requiring warmth. On opening day in 1875, a reporter for the *Cincinnati Commercial* compared it favorably to a "first-class freight depot." During the 1930s, it was connected by a 100-foot tunnel to the new barless cat grottoes, but by 1947, as seen below, the *Cincinnati Enquirer* described it as "beyond repair" with "lighting so inadequate that many of its specimens are seen with difficulty." It was replaced in 1952 by a new Carnivore House designed by Kruckemeyer and Strong that was, in turn, transformed in 1985 into today's Cat House.

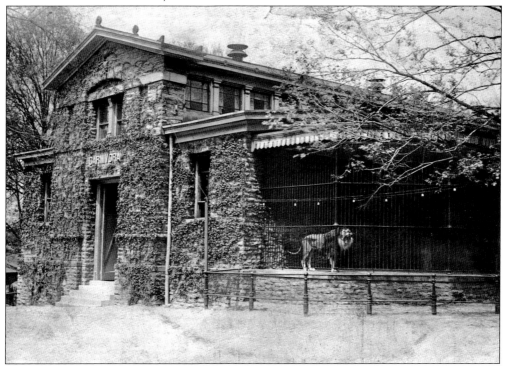

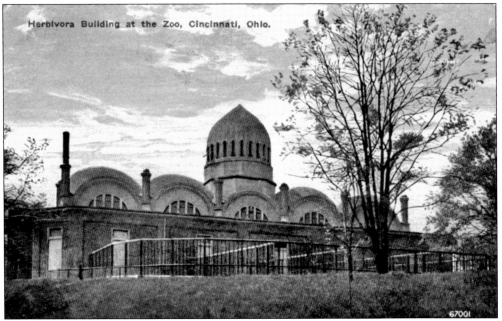

Herbivora Building at the Zoo, Cincinnati, Ohio.

67001

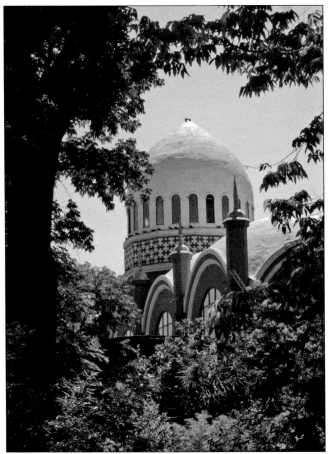

The Elephant House, originally the Herbivora House for hoofed animals, was one of the last of its kind at its 1906 opening. Zoos were moving away from buildings based on the inhabitants' country of origin. But architects Elzner and Anderson wanted something dramatic, worthy of its perch at the highest point on the grounds. Built of concrete, a cutting edge material for the day, its barrel dome and minaret design was influenced by the Taj Mahal. At 150 feet long and 75 feet high, it was the "largest and most complete concrete animal building in the world," according to this souvenir postcard, above. The $50,000 cost was extravagant at the time, and the building, shown at left, has been through several renovations. In 1975, it was placed on the National Register of Historic Places with the Reptile House and Aviary.

Come Up Sometime And See Me In My Bar-less Cage

I'm home most all the time. Enjoy a wholesome day in a healthful atmosphere.

At the ZOO

An advertisement for the zoo in the 1930s invites visitors to see animals in a setting without bars. Influenced by German animal dealer and innovative zoo keeper Carl Hagenbeck, who sold many animals to the zoo, exhibits were constructed on a hillside below the Carnivora House (and connected by a tunnel) using concrete artificial rocks, high walls, and moats instead of steel and bars, beginning a phase of naturalistic renovation.

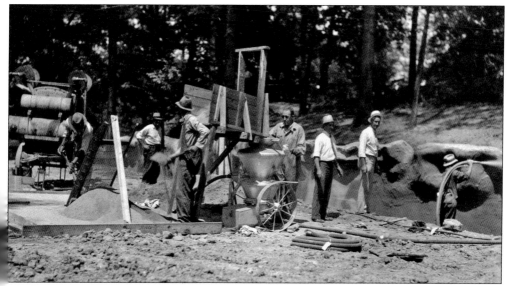

The barless exhibits were built by more than 300 federally funded Civil Work Administration workers. They molded rock-shaped metal framework, then sprayed wet concrete under pressure to create 20-foot-high walls. After drying, the "rocks" were stained to look like natural stone. Joseph Pallenberg, who designed exhibits for the Hagenbecks' German animal park, came to Cincinnati in 1934 to work on the lion and tiger grottoes, the zoo's first barless structures.

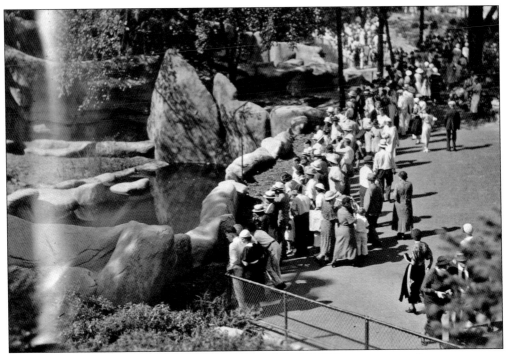

A $24,000 gift by Lilly Ackerland Fleischmann funded the $50,000 grottoes, according to newspaper reports. At the May 1934 opening, the hoopla of a band and a crowd of 3,000 apparently scared the first lion to enter, a male, back into the Carnivora House tunnel. "Persuasion with a prod and stream of water" worked, according to newspaper reports, but "none of the trio showed much curiosity regarding the new surroundings."

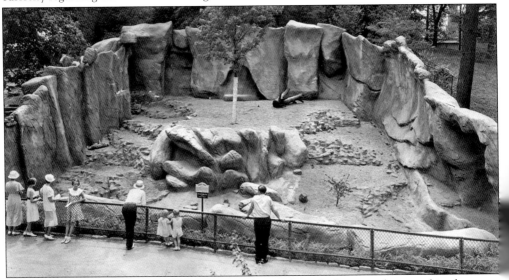

At the grotto opening, five Bengal tigers were driven through the tunnel, jumped in the moat, and "swam about with slow, powerful strokes," according to the *Times-Star*, "blasting the old tradition of the innate hatred of felines for water." The nearby African veldt grotto, plagued by construction problems, wet weather, and a sewer collapse, was delayed in opening until August 25, 1934, when 500 pigeons were released in celebration.

Three

CROWD FAVORITES AND NEWS MAKERS

Zoo visitor surveys often list large animals as major attractions, including tigers, polar bears, and elephants at the top, but the 1875 opening-day accounts gave prominent praise to the 400-plus birds in the collection and the dogs that included "the Italian greyhound, the badger dogs, the King Charles, Danish hounds, the St. Bernard life-savers, a dozen different kinds of trick dogs . . . and an armful of beautiful poodles," which would be oddities in today's zoos.

Conqueror the bull elephant was not even mentioned. A pair of grizzly bears was described by a reporter as "two of the finest specimens we ever saw." But perhaps that was because many of the exhibits were unfinished, leaving crowd-pleasers, including the "heavy biters," in their crates. Yaks were unenthusiastically described as "pleasant cow-like personages that seemed too highly honored by the attention and space bestowed upon them."

However, an alligator escaped and took refuge in the lake, and the resulting news story of its capture a short time later kick-started the zoo's lovefest with the community's newspapers and storytellers that endures today.

The legendary Sol Stephan, then the aforementioned Conqueror's keeper, suggested releasing the many waterfowl from their cages. The superintendent refused "because an alligator had escaped its enclosure and was in the lake," said Stephan in a 1930 *Times-Star* column by Frank Grayson. "So Sol alerted the press and went out in a boat, snagging the alligator by stabbing it through the leg, then relocating it. It lived another 25 years," Grayson wrote, and went on to quote Stephan: "We got good press and began to feed the papers daily animal stories, all amazing, all true." The zoo had entered the world of public relations.

News reports through the years included escaped animals (which often showed up in Avondale backyards, startling residents), battling wildcats, crazed elephants, miniature pachyderms, a love affair with chimpanzees and gorillas that continues today, many births, and reverence tinged with regret for the last animals of two species dying at the zoo.

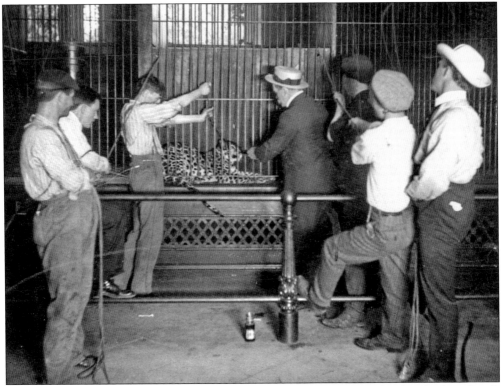

To treat large cats, Sol Stephan, wearing a suit in this 1898 photograph, placed a board with a center ring in the cage. After the "patient" was released into the cage, the board was pulled forward, pinning it. In a 1930 *Times-Star* column, Stephan described using this to treat an abscess on the tiger Rajah: "He fought like #*% but in a few days he was as frisky as ever."

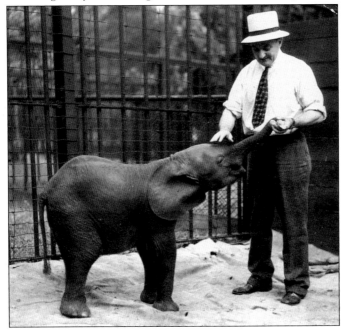

In the September 14, 1931, *Cincinnati Enquirer*, pleas were made for a "friend of the zoo" to buy a pygmy elephant that had become available for the park's 56th birthday. Judge Alfred K. Nippert volunteered, and the diminutive elephant, shown here at her first photograph shoot with zoo assistant general manager Joseph Stephan, arrived. She was only the second of her kind in the country at the time.

Gimpy was the name chosen in a contest for the pygmy elephant, shown here full-grown. In 1931, assistant general manager Joseph Stephan received a call from a steamer captain who first spotted her "playing among the huts of a pygmy tribe in Equatorial Africa." She grew to be 6 feet tall, weighing 2,500 pounds. She was about seven years old when captured and was about 35 inches tall, weighing 300 pounds.

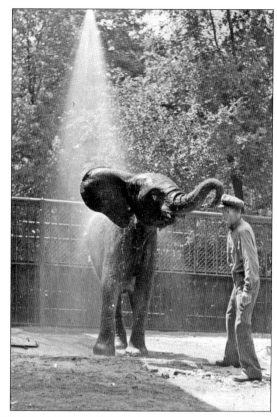

Male lions were early favorites, and vicious reputations always enhanced the hype. Brutus, an 1890s lion, shown below, and Nero, a 1920s lion, were coincidentally described in separate guidebooks as "one of the largest in captivity" and "trained for the arena but sold to the zoo when he became too hard to handle." Both were reported to weigh 500 to 700 pounds, despite Sol's Monday fasting schedule to battle lethargy.

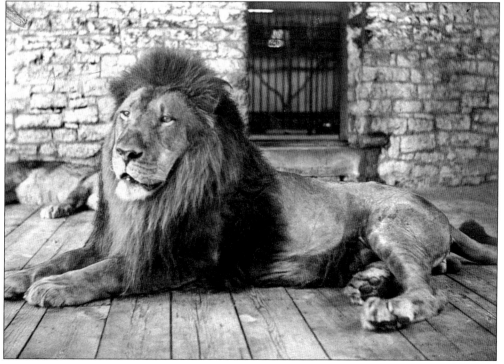

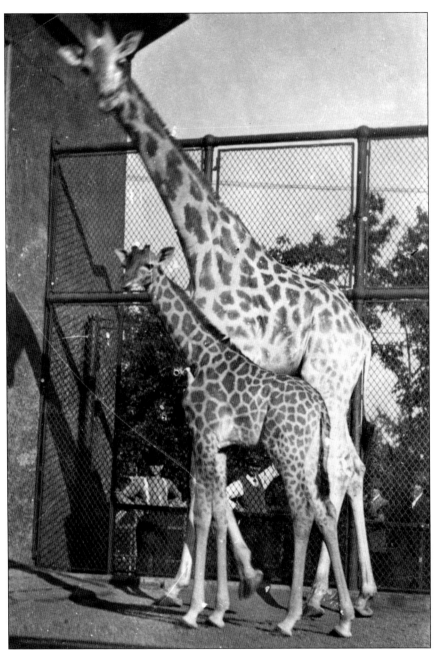

The third time was a charm for the zoo after two unsuccessful giraffe births at the dawn of the 20th century. In September 1910, Kermit and Alice, named in 1905 for two of Pres. Teddy Roosevelt's children, became parents to a female who thrived, reaching 14.5 feet tall. Unfortunately, when the baby giraffe was eight months old, mother Alice died from fright. She was said to be terrified of thunderstorms and would "stand in one place and tremble all over." One of the earlier male giraffes, purchased in 1877, and the father of the first giraffe born at the zoo, was mounted after death and displayed in the Carnivora House, a common practice in the early years. After years being housed in the Elephant House, giraffes are kept in today's more spacious Giraffe Ridge, opened in 2008, one of the most popular exhibits.

The first baby giraffe conceived and born in captivity in America arrived on October 20, 1889, weighing 125 pounds and measuring 5 feet, 5 inches tall. A saccharin newspaper account reported that the father, Abe, "kissed the mother's face and licked her chop as if to say 'you've done your duty.'" But mother Daisy failed to nurse, and the baby died. It was mounted, shown at right, and displayed in the Carnivora House.

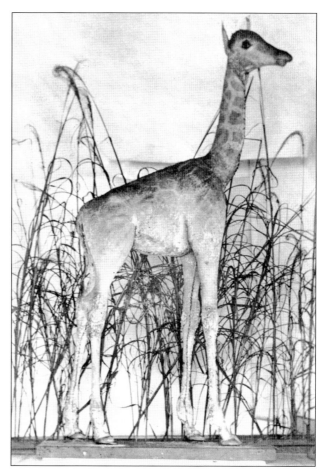

This constrictor, the smaller of two at the zoo in 1904, is being bandaged to treat an abscess from an attack by a larger, 25-foot-long snake that had been "purchased by the foot" for $400. Supt. Sol Stephan discovered in 1892 how painful a python's backward-facing teeth can be when his hand was "swallowed to the wrist" while moving some snakes. A tooth was later found embedded in his thumb.

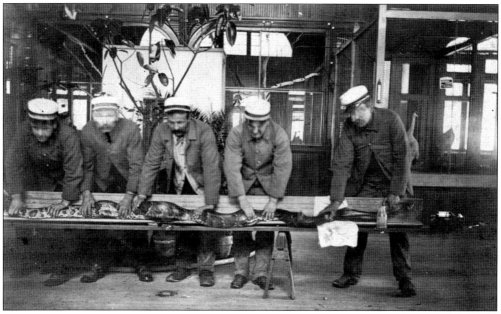

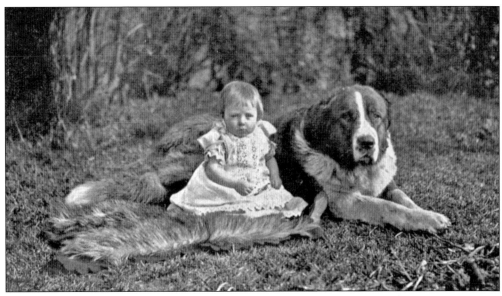

Not all the animals at the early zoo were wild "man-eaters and biters," as the newspapers were fond of describing. The opening-day 1875 menagerie included 13 dogs, with a Newfoundland and two mastiffs, poodles, Danish hounds, greyhounds, and "trick dogs." By 1893, St. Bernard dogs, described as "the largest, noblest and handsomest" of dogs, were held in high esteem, "docile, always sagacious, and faithful to his master but a terror to tramps and evil-doers." Mardo, shown in the above photograph with the baby, was billed as "one of the tallest in the country." The advertisement below is from a zoo program offering "royally-bred puppies" for sale. The well-bred dogs could be traced through studbooks through America, England, and Swiss specimens.

St. Bernard Dogs.

ROYALLY BRED PUPPIES FOR SALE AT LOW PRICES
 AT THE

Inquire of ◣ZOOLOGICAL GARDENS.
or address

S. A. STEPHAN, Superintendent,
OFFICE AT THE ZOO,

or C. F. McLEAN, Secretary,
Office, No. 14 Commercial Gazette Building, Cincinnati, O.

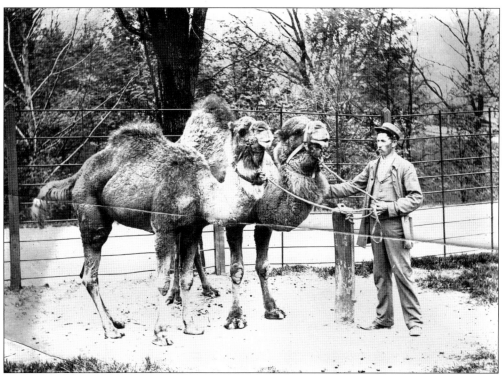

Camels have been crowd-pleasers at the zoo since its opening day when the two Bactrian (two-humped) camels were described as having "well-manured slab sides" in the *Cincinnati Commercial* newspaper. Through the years, the zoo has had Dromedary, or Arabian, (one-humped) camels as well, shown above with longtime zookeeper Ed Coyne. Camel and elephant rides, recently discontinued, were popular, especially with children.

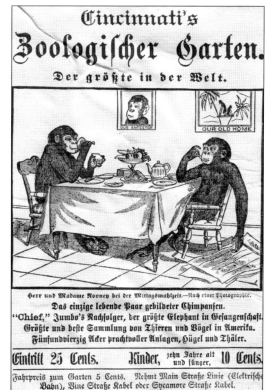

German influence in the zoo's history is apparent in the name of its founder, Andrew Erkenbrecher. German newspapers were plentiful in Cincinnati, and the first guidebook, in 1876, is titled *Fuhrer Durch Den Zoological Garten zu Cincinnati* ("A Guide through the Zoological Garden to Cincinnati"). This newspaper advertisement touts Mr. and Mrs. Rooney, "the only living pair of trained chimpanzees," as well as "Chief, successor to Jumbo the biggest elephant."

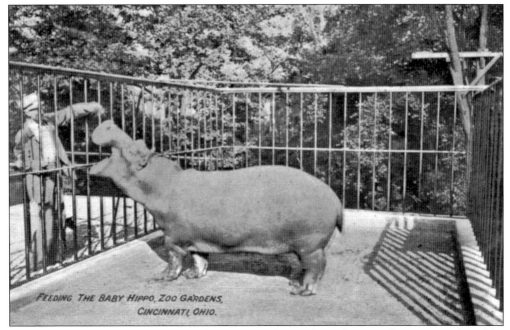

FEEDING THE BABY HIPPO, ZOO GARDENS, CINCINNATI, OHIO.

Zee-koe was king from 1902 to 1923 with an appetite for anything thrown in his cage. Purchased for $3,000, the three-ton giant was captured as a baby and was believed to be the largest hippopotamus in captivity. Zee-koe died in July 1923, and an autopsy showed he swallowed a tennis ball as well as hairpins, coins, and a mesh purse. He was mounted and displayed at Chicago's Field Museum.

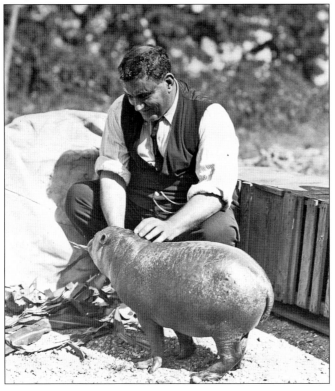

Pygmy hippopotamuses were considered quite rare when Australian trapper Ellis Joseph, shown here, delivered this specimen in October 1927. Five of the river-dwelling animals were first captured in 1913 for the Hagenbecks, German animal dealers, and were quite costly. In order to transport them, Heinrich Hagenbeck described stations arranged in the jungle where dozens of goats "are housed ready to succor these babies," barely 8 inches high, along the way.

Chief was a notorious, five-ton Asian elephant imported in 1872 and trained by John King of the Cincinnati-based Robinson Circus. King, who taught Chief to attack everyone but him, was crushed to death by Chief in Charlotte when, in a drunken state, the keeper insisted on unloading his charges in the dark. Chief then ran into town wreaking havoc, until subdued, and sat upon, by Tillie, another elephant. After further mistreatment to subdue Chief, including raising him by block and tackle several feet above the ground, tying his legs and building a fire under him, he was retired to the zoo. That plan, and Chief, went awry, and he was shot four times in the heart on December 10, 1890 at 4:00 p.m. He was mounted and displayed first in the Carnivora House, then later at the University of Cincinnati. A *Hotel Mail* article reported a "rather unusual dainty loin of elephant" was served December 27 at the Palace Restaurant, "part of Chief the vicious elephant . . . and not bad eating." (Courtesy of the Archives and Rare Books Library, University of Cincinnati.)

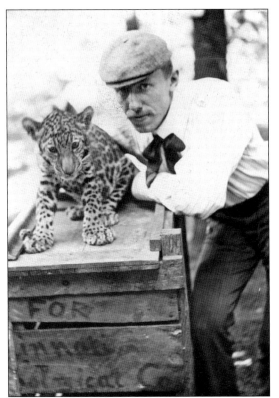

The Hagenbeck Thierpark, near Hamburg and run by Carl Hagenbeck and his two sons Heinrich and Lorenz, was a main animal source for the zoo. This leopard cub being held by an unidentified worker sits atop its crate marked "For Cincinnati Zoological Co." The Hagenbeck animal catalog of December 1898 lists African leopards at $125 each and a Sumatra leopard at $175. Prices included shipping to Hoboken.

This quarter-mile oval track, where children could ride regular ponies, Shetlands, donkeys, and drive carts, was added in 1877 in a spot just west of today's Insectarium and Nocturnal House. Adults could rest and watch in an amphitheater. Hatnee, then later Lil, both elephants, and camels were usually on hand on the infield for rides under guidance of longtime zookeeper Ed Coyne. (Courtesy of the Cincinnati Museum Center, Cincinnati Historical Society Library.)

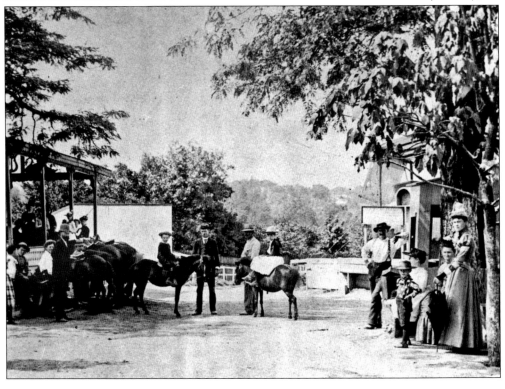

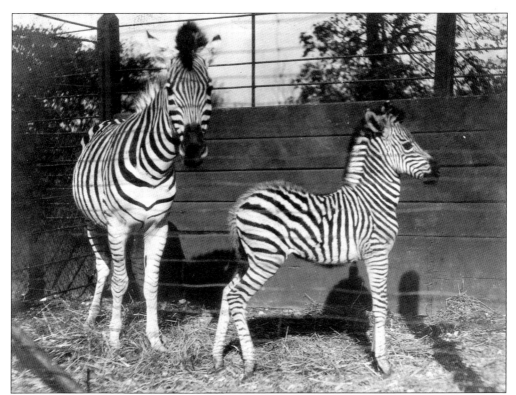

Although zebras were missing from the opening-day list of animals in 1875, they have been a zoo staple ever since, providing a steady stream of newborns, including this youngster from the 1920s. A newborn zebra can stand, walk, and even run with the herd within an hour of its birth. Johari (Swahili for "jewel"), born in May 2007, was the first Grevy's zebra to be born in Cincinnati.

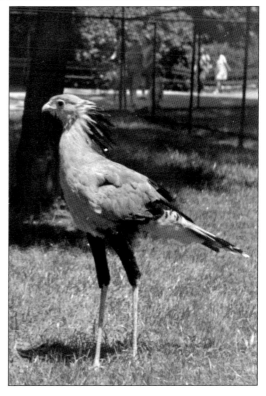

Cincinnati was one of the first zoos to house and show the African secretary bird, which looked like a hawk on stilts. The pair at the zoo was a hit because they stomped on their prey, putting on quite a show when snakes, their favorite meal, were served. The name is thought to come from the crest of feathers echoing the look of quill pens tucked behind a secretary's ear.

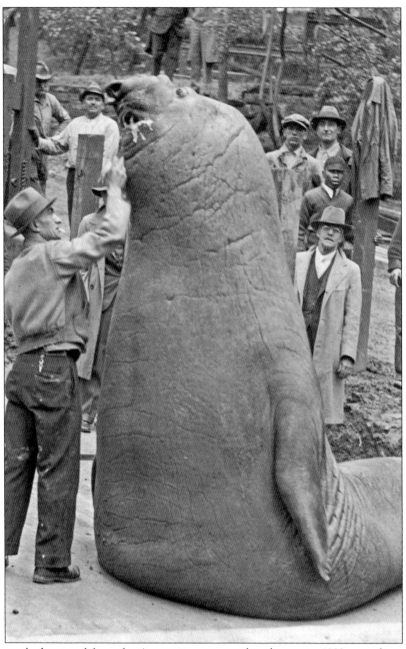

Goliath, an elephant seal from the Antarctic, summered at the zoo in 1933, compliments of the Ringling Brothers Circus, according to the *Cincinnati Post*, giving it a break from traveling around the country in its specially built train car. A tank was built for it on the site of the old ice rink, and it caused quite a stir, according to the newspaper. Measured at 17 to 18 feet and weighing in at "about three tons," the sea elephant, named for the 8-inch collapsible snout that many thought was "trunk like," ate "hundreds of pounds" of fish a day. It was one of two elephant seals purchased by the Ringling Brothers Circus from the Hagenbacks, German animal dealers. The specimen visiting Cincinnati was actually the smaller of the two and had an alias, Colossus. The larger specimen had died in 1929.

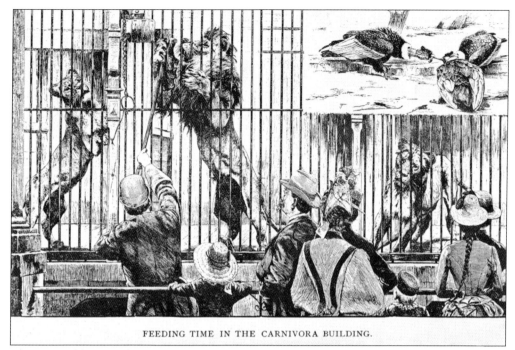

FEEDING TIME IN THE CARNIVORA BUILDING.

The zoo quickly learned that watching the animals feed, especially the meat-eaters and vultures, was fascinating for visitors, so it posted a schedule in *A Book about the Zoo* in 1893 with this drawing. Pelicans were fed at 2:30 p.m., chimpanzees at 3:30 p.m., the big cats at 4:00 p.m. Zoo legend Sol Stephan believed the big cats should skip Monday feedings to keep them from getting lethargic.

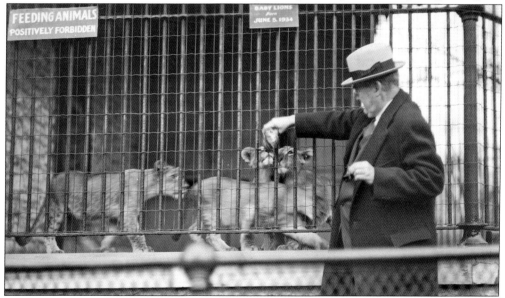

Zoo Babies is a modern promotion showing off new births each spring. But even in the early days, babies got special attention, including these four lions born in June 1934. James A. Reilly, president of the Cincinnati Zoological Society from 1932 to 1950, is shown in this November 11, 1934, photograph hand-feeding the lions despite the "feeding animals positively forbidden" sign posted on the cage.

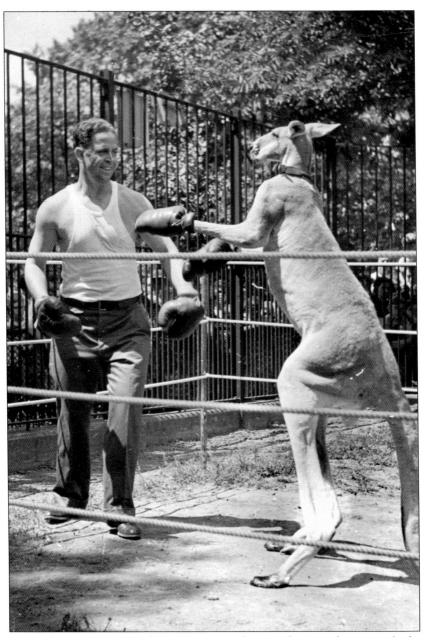

From the time chimpanzees Mr. and Mrs. Rooney took up residence at the zoo in the late 1880s, showing an aptitude for dressing in human's clothes and eating with utensils, visitors have been fascinated with animals mimicking and interacting with humans. One of the most publicized interactions, between Rodney the boxing kangaroo and trainer Howland Kirby in a makeshift ring in August 1940, drew protests and a front-page letter to the editor to the *Cincinnati Post* from an outraged reader. The writer said the exhibition represented a "fine example of the backward trend of civilization." The zoo insisted, "it affords the kangaroo relaxation." Fortunately zoos eventually saw the light and now encourages visitors to appreciate their wards in their natural setting. But all is not lost for boxing fans. Left to their own devices, kangaroos can be found at zoos (and on YouTube) practicing their pugilistic moves with each other to settle dominance issues, sans the gloves.

Rodney the kangaroo was a formidable opponent in the ring, even when hampered by boxing gloves and a keeper standing by with a prod in the background, as in this 1940 photograph. The marsupial's skills included jabs, body-hugging grappling, and kickboxing. The real threat for Howland Kirby, the human opponent, rested in the kick of the kangaroo's hind legs, both at one time, when the animal used its tail for balance.

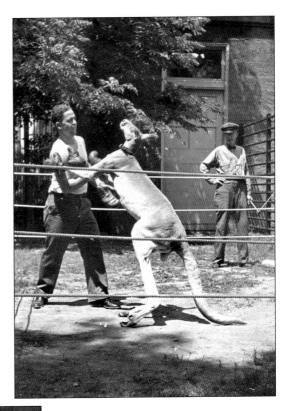

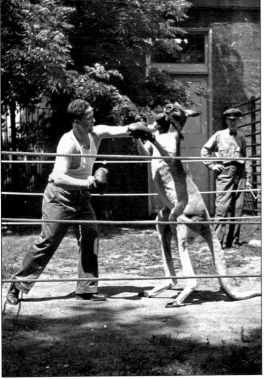

According to newspaper clippings of the event, Rodney "looked forward to the exercise" and would jump around in anticipation when Kirby approached the cage carrying the gloves. Today this type of event is rare. However, it still occurred as late as 2006 in China at the annual Animal Olympics at the Shanghai Wild Animal Park.

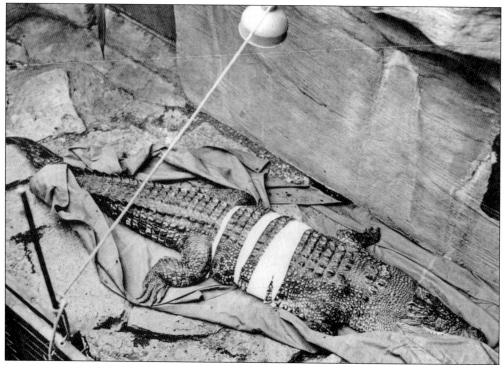

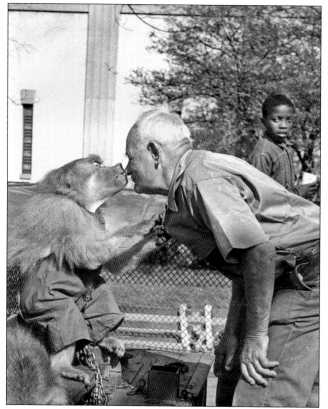

Cleopatra the crocodile made national news when she required the services of veterinary surgeon Dr. Carl A. Pleuger in January 1950 for a bellyache caused by ingestion of "six soft drink bottles and 30 stones." Cleopatra is shown bandaged and resting under a heat lamp to hasten recovery after the "retrieval" of the objects.

In the mid-20th century, most zoos could not resist dressing up gorillas, chimpanzees, and other primates and teaching them human tasks. Baboons were no exception. Zoo trainer Joseph Cogozzo is shown getting a kiss on the nose on May 11, 1955, from a Hamadryas baboon from Abyssinia, or Ethiopia, considered a sacred animal to ancient Egyptians, who depicted them as holy attendants of Toth, scribe to the gods.

Sea lions became stars when the first pool was built in 1877. The annual report boasted having the biggest "sea lion tank and the finest specimens . . . in the world." In 1878, the first pup bred and born in captivity made the record books, though it later died. Daily shows were held mid-century, when this photograph was snapped of trainer and former zoo superintendent Millard Owens and Surf.

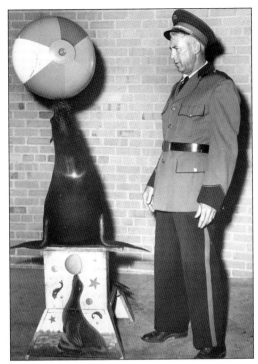

There are two Schottzies in zoo history. The first was purchased by Charles Schott, shown here in the 1960s. His widow, one-time majority Reds owner, the late Marge Schott, purchased today's Schottzie, born in 1975, who was a guest at the Reds Opening Day ceremonies, tossing the first pitch in the late 1990s. Trainer Cecil Jackson Sr. worked two months to teach her to throw the ball instead of eating it.

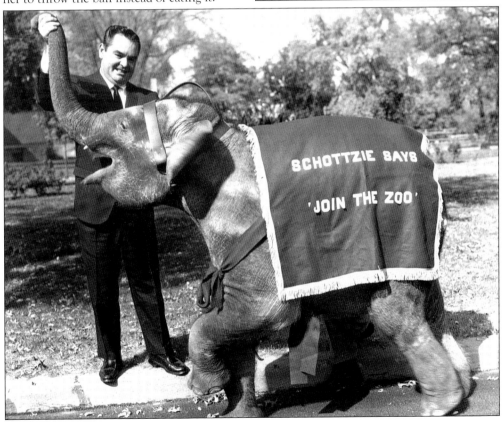

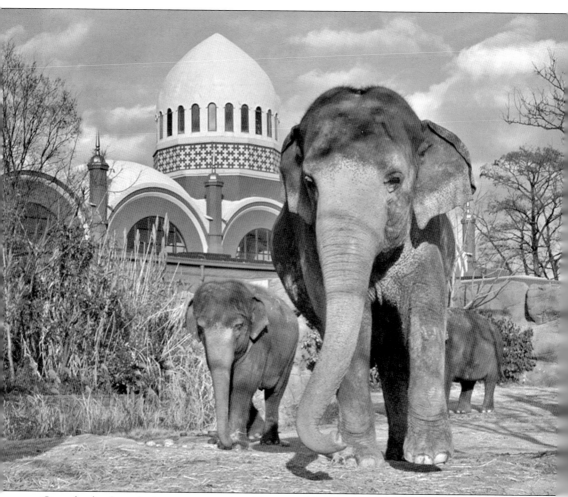

Ganesh, the first elephant conceived and born in Ohio since the Ice Age, created a hoopla on March 15, 1998. Thousands of visitors lined up to get a glimpse of the 3-footer, who weighed in at 213 pounds. Parents were mother Jati, seen with Ganesh in the photograph, and Sabu, both born in the wild. A contest was held to name the newborn Asian elephant, a male, and Ganesh, the Hindu god of success was chosen. A celebration was held each year on his birthday until 2003, when he went to the Columbus Zoo for "temperamental" reasons. It had the room necessary to accommodate male elephants. Ganesh, however, died in 2005 of the highly fatal elephant herpes virus, a strain of herpes that is specific to elephants. His parents remain a part of the newly expanded Asian Elephant Reserve. (Photograph by Dave Jenike.)

Pacific walruses Aituk, seen in the above photograph, and Bruiser, captured in 1978, were literally the biggest and perhaps noisiest draws to the zoo in the early 1990s. An exhibit built for their 1987 arrival near the original sea lion pool included an underwater window. The female, Aituk, gave birth to a 117-pound calf that died. After Aituk died in 1995, Bruiser was loaned to the Brookfield Zoo, then Sea World Orlando.

A trio of Pacific walrus pups from the St. Lawrence Islands became the center of attention in May 1996 when they took over the marine mammal exhibit. Crowds gathered to watch females Patu and Siku and the male, Tuwak, noisily awaiting their meals and splashing visitors. Siku, however, died of an intestinal blockage in 1998, and Patu and Tuwak died in 2000. Then sea lions took over the exhibit.

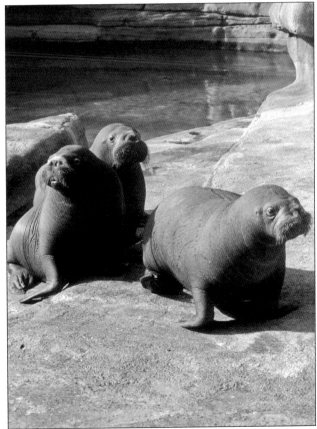

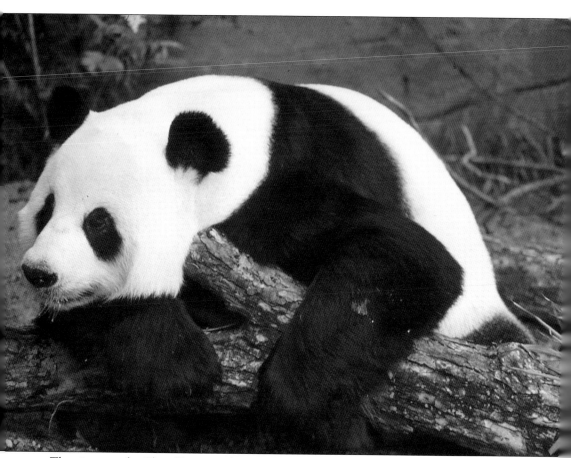

The giant panda, Chia-Chia, a male, traveling from the London Zoo to a breeding program at the Chapultepec Park Zoo near Mexico City, stopped off in Cincinnati in 1988 for a stay in an exhibit built to mark the City of Cincinnati's bicentennial. "The giant panda is a superstar," said Ed Maruska, zoo director at the time. "It's the most important animal we've ever had here." Attendance records were set during the six-week stay, though the *Toledo Blade* reported that the exhibit was initially shut down for a time because the panda would not come out of its den and was acting strangely. "'Homesick' is exactly the word for what's wrong," said the London Zoo representative who was traveling with Chia-Chia. Profits from the stay went to fund panda breeding facilities at the Chapultepec Park Zoo, the first outside China to raise a giant panda. Chia-Chia died in 1991. (Photograph by Mike Dulaney.)

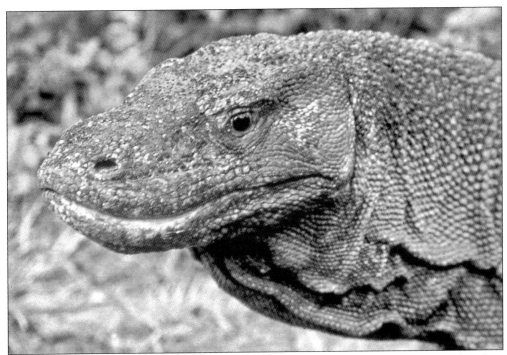

Perhaps the fiercest of newcomers in the 1990s were the Komodo dragons, or monitor lizards, a gift from the Indonesian government to Pres. George H. W. Bush. A substitution had to be made when Wanita, the female arrival, turned out to be a Juan. A female, Sabat, was borrowed from another zoo for Naga, the male, shown here. Their custom enclosure, with heated rocks and a steeply walled outside area, became their home until Naga died in February 2007 at age 24. He was the oldest and largest Komodo dragon in the Western Hemisphere at 9 feet long, weighing 200 pounds. Cincinnati was the second zoo outside Indonesia to breed the endangered animal, which is known for its toxic saliva, razor-sharp teeth, and ability to down prey twice its size. The 32 offspring were given to other zoos. (Photographs by Mike Dulaney.)

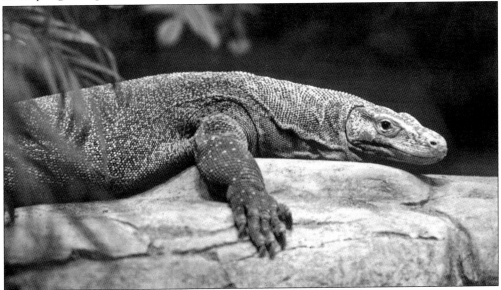

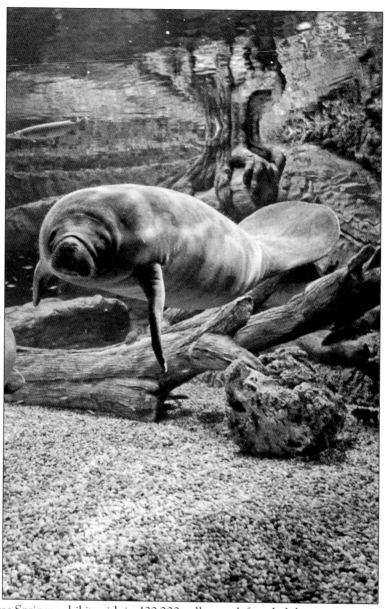

The Manatee Springs exhibit, with its 120,000-gallon tank for rehabilitating injured or orphaned manatees, is a far cry from the first manatee exhibit, sometime around 1907, when one specimen was at the zoo for "a short stay," according to undated newspaper clippings. The dawn-of-the-20th-century specimen, "netted alive under state permit for exhibition purposes," was housed "in a large tank," probably part of a circus at the time. Even in those days, "wanton destruction" of the animal was illegal, with fines of $500. The present-day exhibit, opened in 1999 on the site of the old aquarium, expects two new manatees in the spring of 2010 to exhibit with spotted gar, long-nose gar, Florida gar, and alligator gar in a celebration of Florida's diverse ecology that includes freshwater swamps and mangrove wetlands. Visitors are entranced by watching the 8- to 15-foot-long herbivores, which weigh up to 3,500 pounds, snack on lettuce and other leafy vegetables, and the overnight stays in which children "sack out" along the 38 linear feet of viewing area are a hit.

Four

BREEDING CULTURE

Though located a bit farther away from the city center than originally intended, the zoological garden quickly became a social center, especially in the spring and summer. It is no wonder. Set on a breezy hill, its manicured lawns and colorfully planted formal gardens were a welcome refuge to those who lived in the bustling, noisy city below, surrounded by coal smoke, poor sanitation, horse manure, and, because of Cincinnati's position in the pork business, pigs in the streets.

But it offered more than an occasional diversion.

"The new management then set to work to vigorously stimulate attendance; for experience had taught that no matter how great the collection, something more than the menagerie alone was necessary to keep the public interested," wrote then-secretary of the society Charles E. McLean early on. "Many, and novel entertainments were given; summer night musical fetes were established. They soon became the most popular and fashionable affairs of the summer season. In short, the Garden 'boomed.'"

Zoo culture was born, exposing visitors to popular, classical, and operatic music, theater, endangered lifestyles, foreign customs and products, modern conveniences, and other entertainment options. Education, science, and technology had taken a front seat in the city's development since the Civil War, and improved transportation, including trolleys, streetcars, and inclines, made it easier for people who were tasting "free time" for the first time to visit local sights. They were thirsty for new experiences and knowledge. Expositions touting inventions, and technological advances were popular. Libraries, museums, and parks were the rage.

The zoo became a touchstone for people in the early days, said executive director Thane Maynard, reflecting the heyday of the early days of American zoos. "It's where people went. Imagine 1890, 1900 and when the Zoo Opera started in 1921. There wasn't a lot going on in town. People came not only to see nature's curiosities in these animals but to come out for a community event."

"It really was styled after an old German zoo and botanical garden, this beautiful lush place for people to come on their time off with their families for fun and relaxation."

CINCINNATI

ZOOLOGICAL GARDEN

RESTAURANT

◆◆◆

F. SCHMIDT, - - LESSEE

◆◆◆

Telephone 5134—3.

OPEN EVERY DAY IN THE YEAR.

MEALS and RE-FRESHMENTS of all kinds at no higher prices than you pay in the city.	*LUNCHES and meals a la carte at all hours.*
—	The best of cooking and excellent service.
Regular Dinner from 11.30 a. m. to 2 p. m.—50 cents.	—
	Choicest Wines, Liquors and Cigars.

"Tuesday and Friday Night Musical Fetes are the greatest events of the summer season in Cincinnati," raved newspapers of the day, with "thousands of people representing the fashion, beauty, and intelligence of Cincinnati." Music ranged from military bands, including the German Kaiser's band in all-white uniforms, Sunday concerts by the Cincinnati Orchestra's Reed Band, and popular tunes and patriotic songs and marches.

Food and drink have been a part of zoo history since the opening day in 1875 when a *Cincinnati Commercial* reporter wrote, "People who went in paid 25 cents a head, and marched about among the bears and lions and camels and kangaroos and took their beer like true American citizens." This 1893 menu from the Zoological Garden Restaurant advertised dinners for 50¢, plus "wines, liquors and cigars."

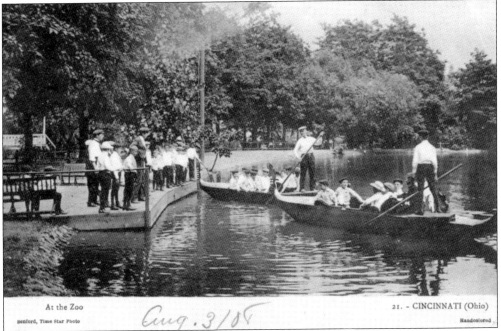

At the Zoo

Benford, Time Star Photo

Aug. 3/05

21. - CINCINNATI (Ohio)

Handcolored

Scenes from Venice was staged on the lake in 1889 with a "cast of hundreds" against a huge canvas backdrop painted by noted local artists Henry Farny and John Rettig. The production's boats were then used to ferry visitors around the lake. Gilbert and Sullivan's *Pinafore* was performed in 1879 and 1885, also using the lake in the production. This postcard with a photograph from the *Times-Star* is dated 1900.

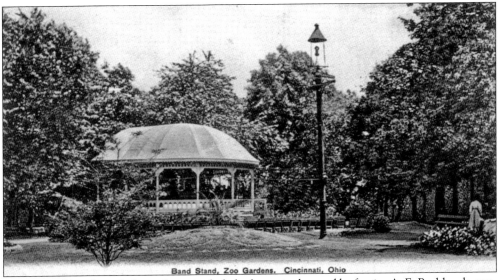

Band Stand, Zoo Gardens. Cincinnati, Ohio

The original bandstand, shown here, included a fountain donated by furrier A. E. Burkhardt, son-in-law of founder Andrew Erkenbrecher. Soon too small for the day's popular singing societies, it was replaced in 1889 with a Moorish-style building by Gustav W. Drach. That, in turn, was replaced by a neoclassical design by Elzner and Anderson in 1911 that was big enough to accommodate the symphony orchestra. It stood near today's Children's Zoo and Gibbon Island.

The Clubhouse and Restaurant, the zoo's social centerpiece, went through many additions through the years that changed its style from Italianate to traditional before it was razed in 1937. It was described as "having broad porches on all sides and can accommodate about 1500 people at a time." The restaurant operator's family also lived in the 150-foot-long building.

COMING! NATURALLY, YOU ENJOY A GOOD SHOW. **NEXT WEEK**
SO, OF COURSE, YOU'LL WANT TO SEE THE

"A Collection of Stars"
— IN A —

Gorgeous Revue of Song, Dance and Comedy

Each Evening, 8 o'clock, August 17th to September 7th, inclusive

FEATURING

ALBERTI PANTOMIMES—"Gesture made fluent, beautiful and expressive."
DADDY GROBECKER'S SWISS YODELERS. LORNA DOONE JACKSON—Contralto.
JOSE MÓJICA—Tenor. STEELE & WINSLOW—"In Poetic Motion."
ALBERTINA RASCH and the Albertina Rasch Dancers. CARTIER & ZANOU—Dance Interpretations.
LEO deHIERAPOLIS—Baritone. GUNNAR BOHMAN—Swedish Troubador.
DAISY CONNELL CHINN—Coloratura Soprano.

The Greatest Collection of Featured Artists Ever Assembled on One Program

POPULAR PRICES: 25c to $1.00. Seat Sale Now

Reserved Seats at Times-Star Building (First Floor). Phone Canal 6023

BESIDES—Only a few weeks remain in which to enjoy those delicious Chicken, Steak and Roast Duck Dinners at the Zoo Club House

ICE SHOWS DANCING

This 1920s advertisement presents an eclectic bill of entertainers at "Zoo Frolic," a change from the classical performers of the early days. Albertina Rasch was a ballet-trained performer with the Ziegfeld Follies, and contralto Lorna Doone Jackson sang with the Cincinnati Symphony Orchestra in 1924. By this time, three daily ice shows had been added at the 21-by-41-foot Woodland Theatre rink, showcasing the "best professional skaters in the world."

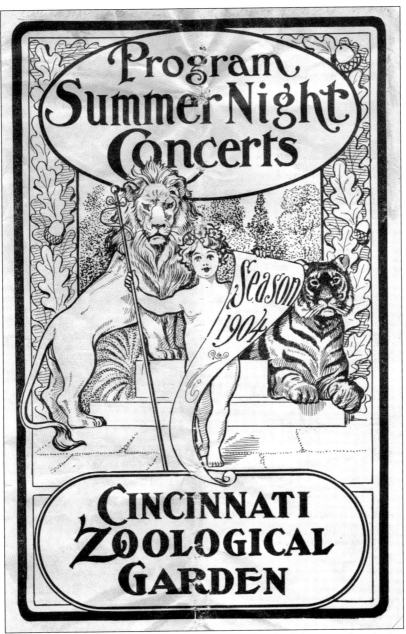

Program Summer Night Concerts

Season 1904

Cincinnati Zoological Garden

The Bandstand, facing the Clubhouse and Restaurant by the lake, was the platform for the popular summer night concerts at the dawn of the 20th century. After a day at the zoo, folks gathered around the bandstand or on the verandas to "people watch" and be treated to the latest popular and classical music performances. Military bands and string orchestras were especially popular. This August 21, 1904, program for a Summer Night Concert listed waltz music, piccolo, cornet, and soprano solos, *Babes in Toyland* excerpts, an Indian sun dance, a ragtime selection, and a vocal quartet. In an 1898 editorial in the *Cincinnati Lancet-Clinic*, a weekly medical news journal, the Summer Night Concerts are described as "not only good so far as the music is concerned but the patronage has been by the very best class of citizens, all improper characters being rigidly excluded."

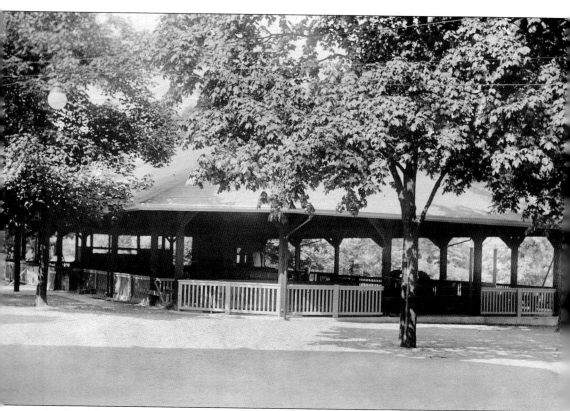

With all the music being performed in the early years, it was only natural to include dancing in the entertainment mix. In June 1920, a 5,000-square-foot Zoo Dansant opened with a "perfect maple" floor, rustic timbered columns, and a sloping roof similar in style to picnic pavilions of the day. It was located near today's Rhino Café and described as "a high-class dance floor" in zoo guidebooks. Each evening, from 7:30 p.m. to 11:30 p.m., in the summer season of May to September, couples twirled about to popular tunes of the day, paying 5¢ per couple per dance. There was also dancing, at no charge, before and after concerts and operas and during intermissions on the Clubhouse and Restaurant balcony, which also had a maple floor. "The best dance music available is provided at both of these dance floors, and proper discipline is maintained," according to an early guidebook.

Take Red Electric Cars

— FOR THE —

ZOO

Main Street or Fountain Square

THE ONLY LINE
THAT CARRIES YOU TO
THE GARDEN

NO OTHER
STREET RAILWAY GOING NEARER
THAN THREE-QUARTERS
OF A MILE.

Through Fare, 5 Cents.

The Mount Auburn Street Railway was the closest public transportation to the zoo at its opening in 1875, running from downtown's center, a distance of 3 miles, to within 1,000 feet of the entry gate at today's Vine Street and Erkenbrecher Avenue. The fare was 5¢. Inclines and steam-powered cable cars made the trip easier, and by 1887, a narrow-gauge railroad was extended to the zoo. A plaza was built, designed to look like one at the Berlin zoological garden, to receive cable cars. Horse-drawn cars to the zoo were more expensive, at 10¢. The Mount Auburn Incline, built in 1872, ran from the head of Main Street to the crest of Mount Auburn Hill, but the most popular route to the zoo was the Zoo-Eden 49, which ran up the Mount Adams Incline. The last of Cincinnati's inclines, it was completed in 1872 and closed in 1948.

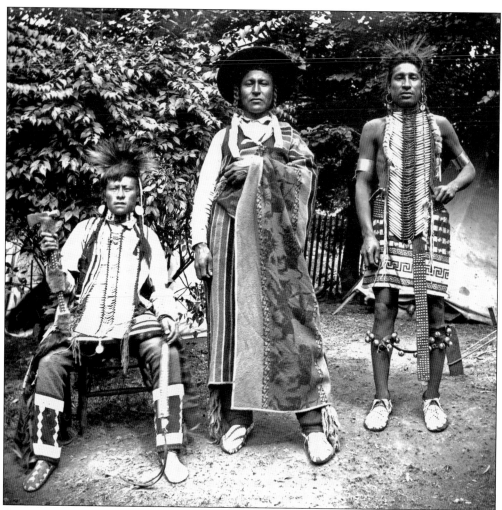

Cincinnatians were fired up by Wild West shows and mythical frontier nostalgia when a showman abandoned a band of Cree Indians in 1895 in Bellevue, Kentucky. Inspired by the ethnological "exotic people exhibits" popular in Germany, zoo administration saw an opportunity and invited them to camp on zoo grounds for two months, boosting the coffers by $25,000 and funding their return to Montana. The "cultural" program also featured an Oriental village, with Arabian, Kurdish, Armenian, and Egyptian families in ethnically diverse tents with medicine dances, stereotypical wagon attacks, and portrayals of massacres. John Goetz Jr., president of the zoological society, justified the decision: "The presentation of wild people is in line with zoology, and so, when we exhibit Indians . . . or any wild or strange people now in existence, we are simply keeping within our province as a zoological institution." In 1896, the Bureau of Indian Affairs gave approval for the zoo to host 89 Sicangu Sioux, shown here, bringing their teepees, horses, and ceremonial gear from South Dakota by train. (Courtesy of the Cincinnati Museum Center, Cincinnati Historical Society Library.)

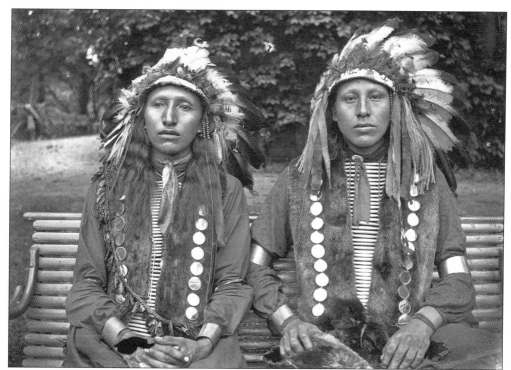

The Sicangu received, per month, $5 for each child, up to $50 for chiefs, and a $10,000 bond was posted for their safe return. They put on two daily shows, at 3:00 p.m. and 8:30 p.m., which included "electric and pyrotechnic lighting and red-fire effects," Native American dances, ceremonies, and slightly altered historical re-creations, even riding with Bedouin Arab horsemen on tour in a Wild West/Wild East chase. They surprised the zoo's German chefs with their taste for the choicest cuts of meat, requesting more vegetables, blackberries, and watermelon. And reporters followed them on shopping trips, cataloging their purchases. Local artists, including many from Rookwood Pottery, arranged photographic sessions for later designs. The summer was a bust economically, by "several thousand dollars," due to rainy weather and competition from other Wild West shows. (Both, courtesy of Enno Meyer from the Cincinnati Museum Center–Cincinnati Historical Society Library.)

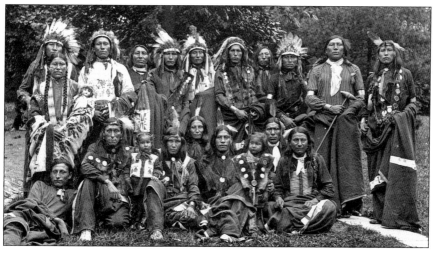

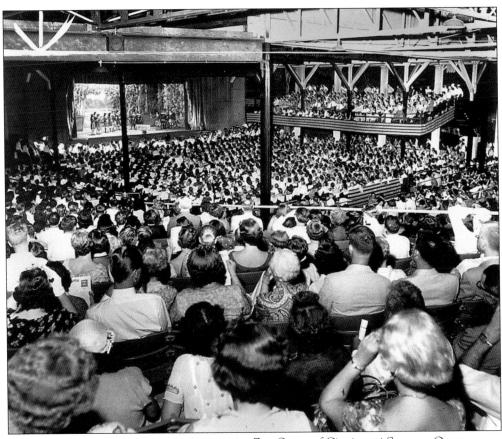

GRAND OPERA
LIBRETTOS

ITALIAN
AND ENGLISH TEXT
AND MUSIC OF THE PRINCIPAL AIRS

AÏDA

BY
VERDI

OLIVER DITSON COMPANY
BOSTON

CHAS·H·DITSON & C°
New York

LYON & HEALY
Chicago

Zoo Opera of Cincinnati Summer Opera, started as an extra attraction in 1920, struck a chord with Cincinnatians looking for a little outdoor culture with their wildlife and went on for 50 years with world-famous performers, including Roberta Peters, John Alexander, and Placido Domingo. Providing summer employment for Cincinnati Symphony musicians and a "summer camp" for singers, it was described in the *Cincinnati Post* as "strictly black tie, a glamorous affair." (Courtesy of Cincinnati Opera.)

Elephants were always on hand for *Aida*, a popular opera choice because of the animals called for, but the shrieking peacocks and braying donkeys often provided unwanted accompaniment. The zoo productions, an introduction to opera for children, included handouts with translations (in this case English/Italian), as well as scene settings, the plot, and the score.

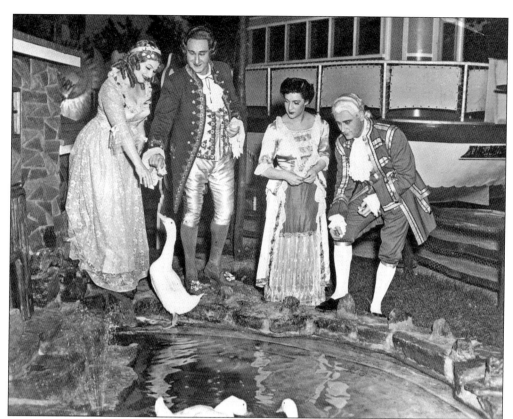

In addition to noisy, impromptu animal interruptions, summer opera performers had to contend with flying insects, sweltering costumes, and a demanding schedule. The widow of opera basso Italo Tajo recalled his complaints about sweating, especially in *Don Pasquale* because of the leggings. And there was only one dressing room, for the soprano, she said in a newspaper article. In the opening 1920 season, there were 42 performances in seven weeks. (Courtesy of Cincinnati Opera.)

Carmen was performed in August 1930 at the zoo, but the decade did not continue on a good note. When the city became the new zoo owner, it was made clear that musical deficits would not be underwritten. Mrs. John J. (Irene) Emery and Mrs. Horace (Jean Maxwell) Schmidlapp put together a fund. By 1933, the Civic Opera Association was organized to produce opera and handle financing under contract with the zoo.

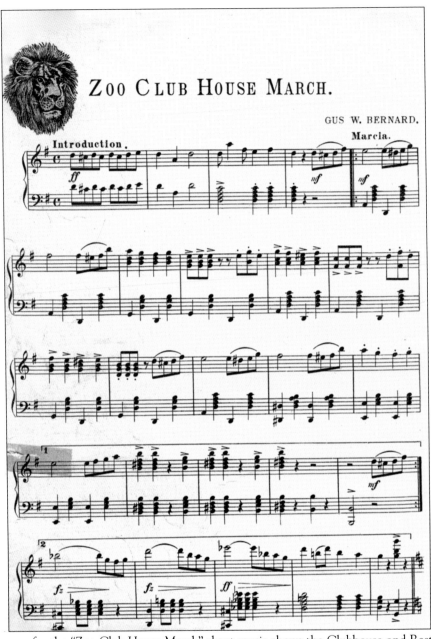

ZOO CLUB HOUSE MARCH.

GUS W. BERNARD.

This cover for the "Zoo Club House March" sheet music shows the Clubhouse and Restaurant with various zoo scenes and reads, "respectfully dedicated to my friend Jos. D. Kueny." The music, by composer Gus W. Bernard, honored Kueny, a French immigrant, proprietor, and chef of the zoo restaurant at the beginning of the 20th century. He was also a chef at the Metropolitan Opera House in New York City and owned hotels in Illinois, Michigan, and Florida. Jingles and their sheet music, often a form of advertising, were popular at the time, and later ragtime music borrowed its form and harmonies from marching music and the Sousa sound. Bernard wrote many commercial jingles and marches, including the "1900 March" and in 1903 a march for Gannymede 76 brand whiskey, distilled by Sig and Sol Freiberg on Fourth Street in Cincinnati. He also wrote a famous cakewalk dance tune, "Colored Aristocracy," in 1899.

Five

MONKEY SHINES

Apes, as humans' closest living relatives in the animal world, are routinely at the top of the zoo popularity list, along with the elephant, hippopotamus, and lion. But in Cincinnati, gorillas and chimpanzees, especially, have been kings of the jungle crowd since chimpanzees Mr. and Mrs. Rooney drew giggles in 1888 by eating with utensils and dressing up in their Sunday best.

Susie, "the world's only trained gorilla," was so popular in the 1940s that she rated her own Crosley refrigerator. Folks planned their visits around her spoon-and-fork dinners with trainer William Dressman, and the symphony scheduled summer zoo opera rehearsals to avoid disturbing her daily shows.

Chimpanzees rode bikes, painted, exhibited in art galleries, and advertised beer for sponsors. Penelope the gorilla, a gift from philanthropic missionary Albert Schweitzer in 1957, started a breeding craze that helped earn Cincinnati the "sexiest zoo" moniker from *Newsweek* magazine.

As naturalistic displays took over and many species took their places on the endangered list, zoos got serious and moved away from vaudeville entertainment, leaving apes to do a fine job on their own thrilling the crowds with chest-pounding, shrieking, climbing, and tending to their young. Zoos took up research, breeding, and innovative approaches to boost declining populations that included artificial insemination, in vitro fertilization, and embryo transfer; this was some serious stuff indeed.

In 1978, the zoo opened one of the first large naturalistic gorilla exhibits on the site of the original Aviary buildings, in which animals and visitors are surrounded by real and simulated rocks, jungle plants, and sounds. A deep moat, not cages or bars, separates visitors from the gorillas' "run" that includes waterfalls, climbing trees, swinging ropes, and hideaways.

Here and in Jungle Trails, home of bonobos and orangutans, the funny clothes are left to the visitors, and the animals can be appreciated for their natural magnificence.

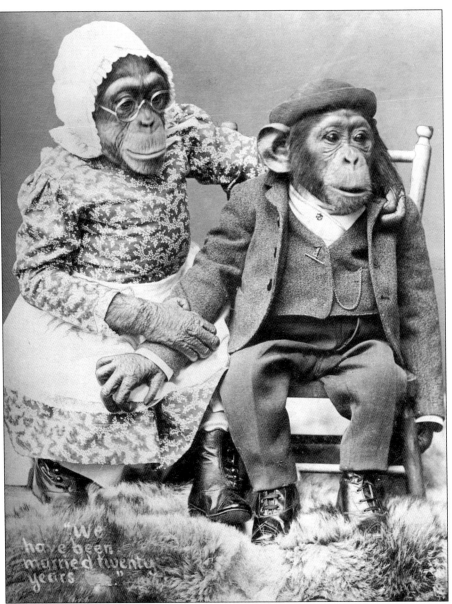

From 1888 to 1894, Mr. and Mrs. Rooney, then the "only two chimpanzees in the United States," lived in the Carnivora House and were named after the male's resemblance to a popular actor when made up for his routine. The actor, whose agent initially threatened to sue for use of his name, eventually visited and, upon seeing the male, said in his stage-brogue, "Howly smoke, but isn't he loike me?" The two apes, partial to rocking chairs, were often dressed in suits, dresses, hats, even shoes, as they are in this photograph, which is inscribed, "We have been married twenty years." Thought to be three to five years old when captured in 1888, they were quick studies in using forks, spoons, cups, and napkins, and visitors crowded around for their 3:30 p.m. daily meal, complete with tablecloth. Kept behind glass to protect them from drafts believed to cause pneumonia, the male nevertheless died in February 1894, and the female shortly after of consumption. One of them was mounted and displayed in the Carnivora Building, a common practice at the time.

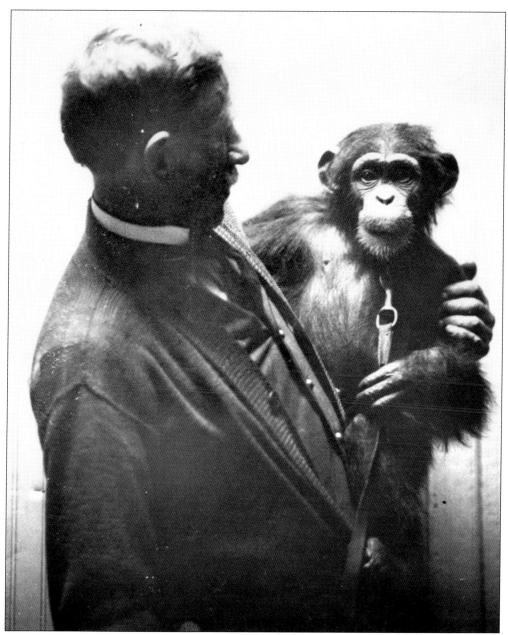

Julia the chimpanzee, shown here in the 1920s with longtime keeper Ed Coyne, came to Cincinnati to replace another table-trained zoo chimpanzee favorite, Tarzan, who died in May 1921 of pneumonia, then a common ailment for captive apes. Tarzan had come to Cincinnati from New York, where he lived in an apartment with a couple who taught him table manners. The new female came from the French Congo, just as Tarzan had, and was purchased for $1,500 to $3,000 from Henry Bartels of New York, a trader who imported exotic animals through Germany. Traveling in a Pullman car "in her own stateroom with her own attendant," according to newspapers, Julia arrived on the Cincinnati Limited in 1923. Renamed Queen on arrival, she was believed to be about three years old at the time. A newspaper reported "she was escorted from the train to a private hot air-warmed room at the zoo."

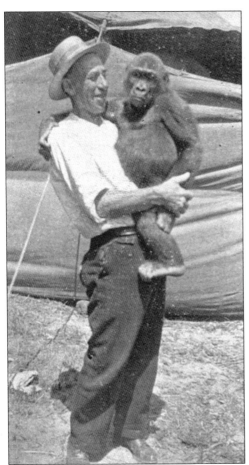

Susie the western lowland gorilla was a wildly popular celebrity, as anyone who visited in the 1930s and 1940s can testify. Susie's story is tinged with sadness, an example of an ape brought up by humans to act like humans but existing in a netherworld between the wild and civilization. Originally named Kivie or Kivi, she was born in 1926 in the mountains of Belgian Congo, where her parents were supposedly "killed by pygmies with poison arrows."

A French expedition purchased the female at "about six months old," and she was exhibited in Europe before coming to the United States on the *Graf Zeppelin* in 1929, traveling as a paying passenger. William Dressman, Susie's escort, became her trainer, and their story was told in a souvenir book featuring this photograph (above). The other photograph is one in a postcard series.

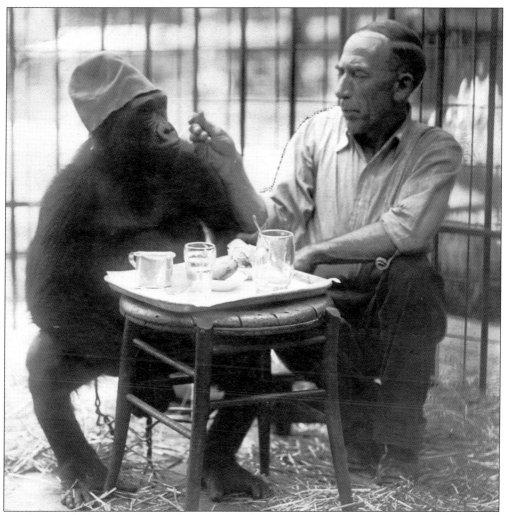

Susie's dining habits, described as "dainty," were of particular interest to visitors who crowded around for the 12:30 p.m. and 4:30 p.m. "meals," taken with William Dressman, above, using utensils, glassware, a dinner bell, and supposedly "white-gloved manners." "Eating about five times that of a 12-year-old girl" in 1940, the meal plan included: breakfast, consisting of a 12-ounce bowl of Cream of Wheat cereal, three raw eggs and milk, three pieces of zwieback (a crunchy toast) and jelly, and one orange; lunch, consisting of a pint of Jell-O, 8 ounces of sliced peaches, pineapple and strawberries, 1 quart of malted milk, three stalks of celery, a head of lettuce, and a handful of fruit; dinner, consisting of one apple, one banana, 1 quart of weak tea with three beaten eggs in it, wafers to dip in the drink, and a bowl of rice and raisins; a 6:00 p.m. snack, consisting of six bananas and three celery stalks, the latter her favorite food. Newspaper reports also revealed that the star had a Chesterfield cigarette every day, but there is no official record that supports that claim. This diet pushed Susie to more than 400 pounds by 1944.

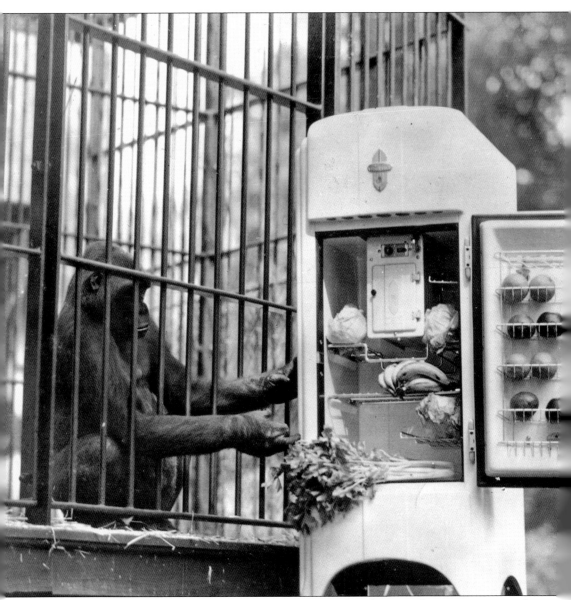

Susie was actually purchased by Robert J. Sullivan, a zoo benefactor, and put on permanent loan to the zoo. But Sullivan took his ownership seriously, complaining about Susie's sweltering summer quarters in a May 11, 1934, letter written to the zoo board from Susie's point of view: "It is wrong and misleading . . . to use my pretty picture . . . to sell tickets. Why not say 'Come out and see me in a glass bandbox where the children can see me suffering from heat while some argue?' If I don't have something damn soon, I will ask Papa Sullivan to send me to St. Louis, and I know he will do it." Three days later, a letter was drafted by the board for the construction of an outdoor cage for $1,900. In 1936, Susie received her own streamline Shelvador electric refrigerator from Powel Crosley Jr., president of Crosley Radio Corporation, to go with her new cage, both shown here. The press release reads, "being an educated lady she liked the beauty of the new streamline model."

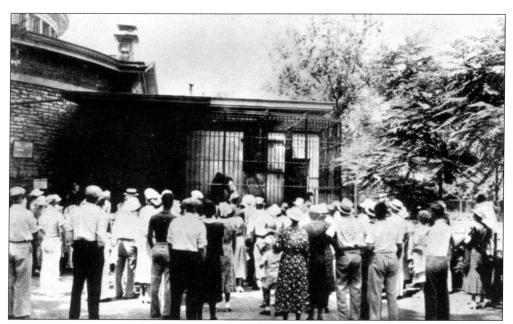

Crowds gathered around Susie's outdoor cage, adjacent to today's Reptile House, every day in warm weather when the "first and only trained gorilla in the world" and trainer William Dressman dined, often exchanging food bites. Susie's August 7 birthday was an annual celebration with free ice cream and cake for children, and people all over the United States mailed cards. The 1936 birthday bash broke attendance records for a non-holiday.

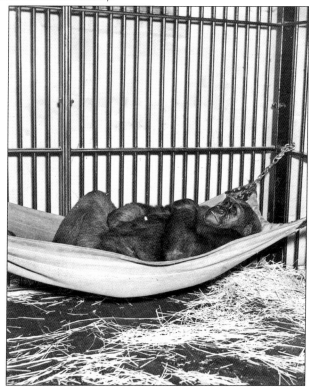

When "lights out" came, Susie bedded down in a hammock suspended about 2.5 feet above a floor covered with straw. The gorilla celebrity always slept with a blanket, even in summer. By January 1944, she was 5 feet, 2 inches tall and weighed 405 pounds with a 56-inch chest and a 66-inch waist.

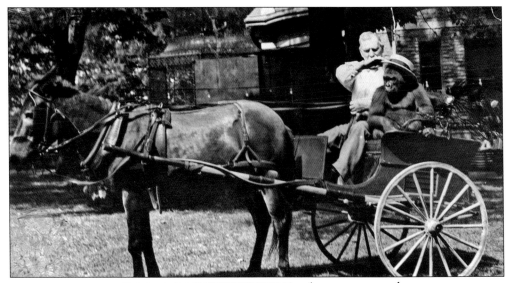

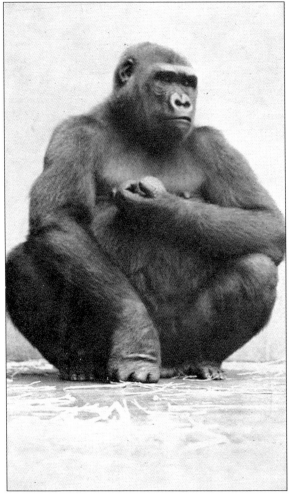

As a youngster, when not entertaining crowds, Susie could be found with zoo general manager Sol Stephan making rounds in a donkey cart, shown in this 1932 photograph. But Susie could be difficult. In 1938, she bit William Dressman's wife, Caroline, requiring three stitches at Good Samaritan Hospital. Susie was then 11 and weighed 275 pounds. She later exhibited behavior problems, blamed on adolescence and her extreme attachment to Dressman.

Though newspaper stories said Susie "never took to riding a tricycle or balancing contrivances," the ape's dining habits were enough to draw crowds, and cards "signed" by Susie were collectors' items. Purchased in 1931 from Reiners and Lucadema for $4,500, Susie died on October 29, 1947. The cause of death was leptospirosis, a bacterial infection, or a stroke. Her skeleton was destroyed by a 1974 fire at the University of Cincinnati.

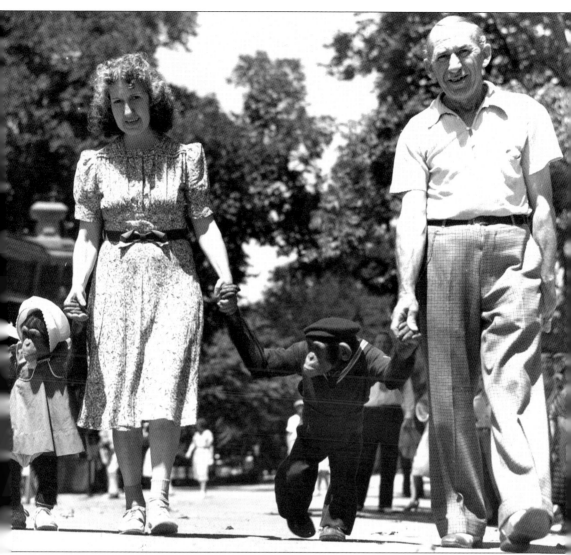

Caroline and William Dressman, shown in this 1940s photograph with chimpanzees Billy and Janie, handled the training of the zoo apes. In those days, zoos often dressed up apes and, taking advantage of their aptitude, taught them to ride bicycles and tricycles and to roller-skate. Billy and Janie could often be found walking through the grounds in summer months with the Dressmans, Billy in a trademark sailor suit and Janie in a dress and bonnet. William, originally from Covington, was working with a New Jersey animal dealer when he was assigned to escort Susie the gorilla around the country for appearances in circuses, sideshows, department stores, and other public venues. After two years, he came with Susie to the zoo, where he met and married Caroline. The couple, who had no children, often said the chimpanzees were like family to them. Caroline became a florist after William died in 1954. She died in 1977.

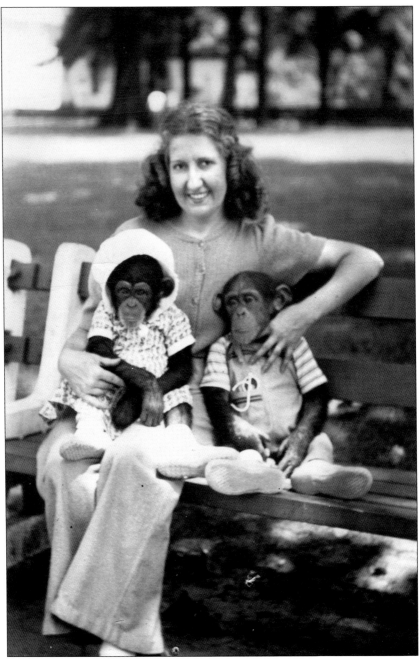

Billy and Janie the chimpanzees are shown in this photograph in their early "toddler" years, with Caroline Dressman, who dressed them up and taught them to ride bikes and roller-skate for daily shows. The *Cincinnati by Ohio Federal Writers Project*, a project of the Work Projects Administration, described them in 1943 as "a pair of trained chimpanzees who eat at a table with solemn punctilio, perform on roller skates and tumble like circus clowns." Dressman accompanied Janie to Hollywood in 1948 to audition for a role in the comedy *You Gotta Stay Happy* with Jimmy Stewart and Joan Fontaine, but a cigar-smoking chimpanzee eventually got the role. One can only assume it was not the lady-like Janie.

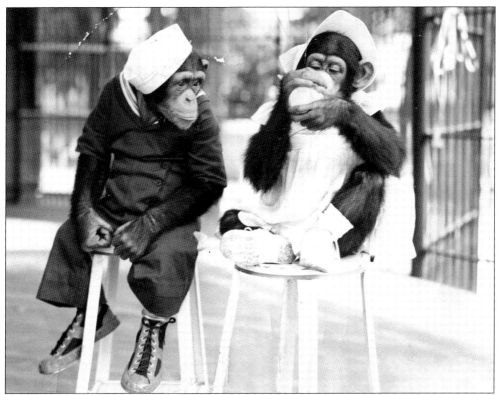

Billy the chimpanzee would sometimes appear in overalls, as in the photograph below, from a Fourth of July zoo celebration in 1943, but most of the time, he sported a sailor suit complete with the cap and high-top gym shoes, as shown in the July 27, 1940, photograph above. Janie, always a lady, was usually seen either toting or wearing a bonnet, dressed in a summer smock, shoes, knee socks, and, many times, carrying a purse. Zoos eventually moved away from the practice of humanizing chimpanzees, allowing them to be appreciated for their natural traits and behavior.

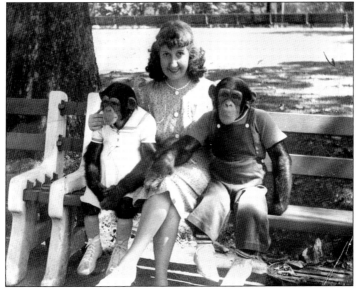

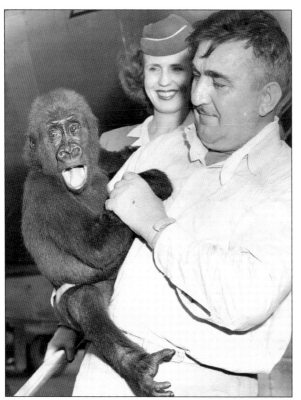

M'golo (Big Boy), a male gorilla born in the wild on January 1, 1946, arrived in Cincinnati with an unidentified stewardess escort in July 1949 to be picked up by zoo veterinarian Byron Bernard, seen in the photograph at left. But before being delivered to his new home at the zoo, M'golo was taken to the *Cincinnati Enquirer* newsroom, seen in the photograph below, for a few publicity shots. M'golo was not quite as charming with the gorilla ladies though. Penelope, a female gorilla, refused to breed with him in later years, reportedly because "M'golo took delight in pummeling her" when they shared a cage as youngsters. M'golo later went to the Houston Zoo, where he died in 1967 with no offspring. Penelope outdid him in the breeding department.

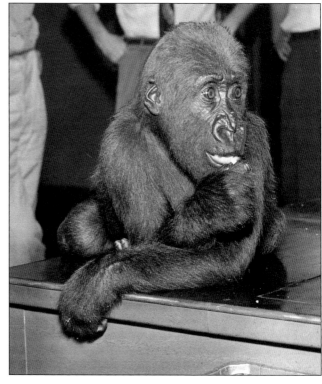

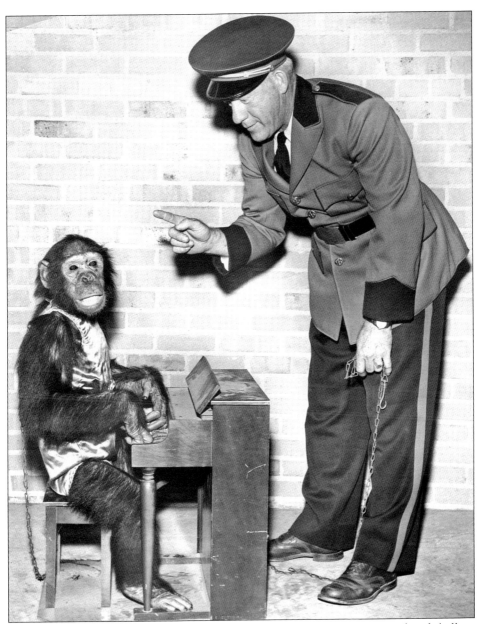

Daily summer shows at the zoo spotlighted seals, usually balancing or tossing beach balls, and chimpanzees doing everything from gymnastics tricks to banging on child-size pianos, riding bikes, and roller-skating. Because of their intelligence, both chimpanzees and gorillas were trained at zoos in those days to sit at a table and eat, often with utensils, but gorillas usually left the physical comedy to the chimpanzees. Years later, when training chimpanzees fell out of favor, many were abandoned by unethical sideshows and circuses. The lucky ones were found and housed in refuges specifically created for past performers. Trainer Rudy Underwood, shown here with Rudy the chimpanzee, spent five of his 30 years at the zoo training chimpanzees. Rudy the ape was named after Underwood when he was born on the trainer's birthday, July 15, in the early 1950s. The chimpanzee was later sent to the St. Louis Zoo, and Underwood's grandson remembers visiting the chimp there on family trips.

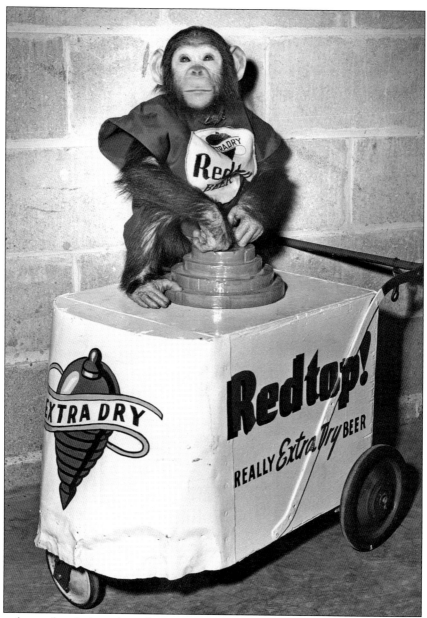

Beer has always played a big role in the zoo's history because of the area's strong German heritage. It was started by Germans, with a design based on German zoological gardens, and many of the animals were purchased from or traded with German animal trader Carl Hagenbeck. The zoo's historical files are full of references to beer, from the opening-day newspaper report that guests "took their beer like true American citizens" to snapshots of keepers feeding beer to bears. By the 1950s, beer was off the animal menu but still plentiful at zoo functions. Chimpanzees, because of their cuteness quotient, were often enlisted in advertising, including this youngster atop a Red Top Extra Dry beer cart. Red Top bought the Hauck Brewing Company on Central Avenue at Dayton Street and was the 14th largest brewery in the United States in the early 1950s, around the time this promotional photograph was taken. It was out of business by 1957, and the brand was acquired by the Terre Haute Brewing Company.

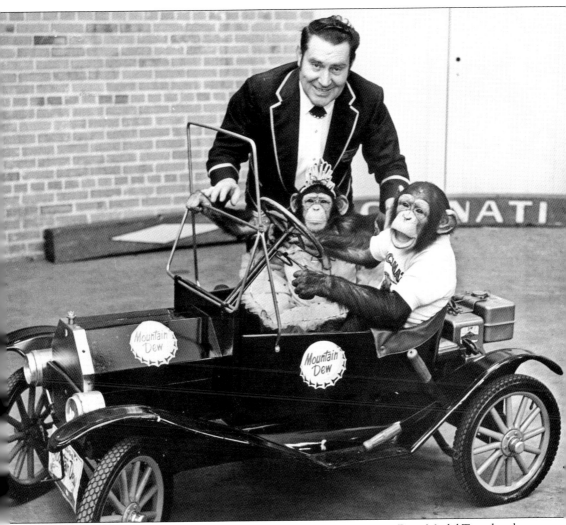

Chimpanzees Susie and Nelson rode around in this mini Mountain Dew Model-T under the direction of Cecil Jackson Sr., longtime employee and trainer who started at the zoo driving a train in the 1950s and worked with horses, gorillas, chimpanzees, and elephants. As an elephant trainer, he handled the task of training Schottzie the Asian elephant to throw out the ball for Reds Opening Day in 1995, a stunt that made national news. Newspaper stories said it took about two months for him to train the beloved elephant, purchased for the zoo by the late Reds majority owner Marge Schott, to throw the ball instead of trying to eat it. But when the big day came, Schottzie "performed admirably" and left a little something on the field for the grounds crew. Jackson introduced his son and namesake to elephants when he was a teenager, and caring for the lumbering giants became his life's work as well.

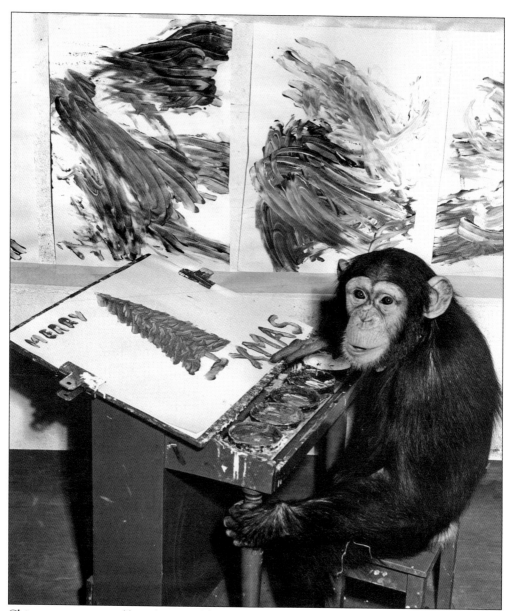

Chimpanzees mastered bicycling, tumbling, even "driving" mini-cars at mid-century zoos, so why not painting? The fad started in the early 1950s, thanks to the popularity of modern art, and spread around the world. Beauty is about three years old in this photograph showing her work on the wall and a "Merry Christmas" design that she obviously did not generate. Beauty, at the zoo since 1958, started painting in April 1961 by sitting at a mini-drawing board with a clipped-on sheet of paper and five containers of gouache in a tray. The female chimp would apply colors, finger-paint style, described as "lyrical abstract impressionism." An exhibition of Beauty's work was held at the Bianchini Gallery in New York City in the fall of 1961 to benefit the zoo. An exhibit brochure describes the ape's work: "These paintings most likely will be compared with current action-paintings. They have in common the fact that they are abstract and the momentum of action communicates itself forcefully. But there the comparison ends." Angel the chimp took over when Beauty lost interest.

Pioneers in the ape-painting craze were Alpha, a female chimpanzee at Yerkes Laboratories in Florida in 1951, and Betsy at the Baltimore Zoo. But the most famous was Congo, at the London Zoo, whose work hung in Pablo Picasso's studio and was auctioned by Sotheby's. The human who played the biggest role was zoologist/painter/author Desmond Morris, who took primate paintings "to indicate an intrinsic motivation for abstract creativity expressed through an exploration of the visual field and color." Painting chimpanzees like Angel, shown in photographs at work for an audience and again with her arts supply box, chose bright colors, never black. The craze died out by the mid-1960s, although elephants picked it up. My-Thai, a Cincinnati zoo elephant, dabbled in paints as late as 2009, and today rhinoceros use their semi-prehensile lips to paint ornaments sold at the zoo.

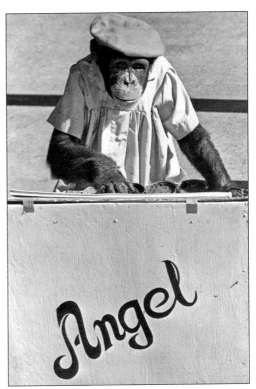

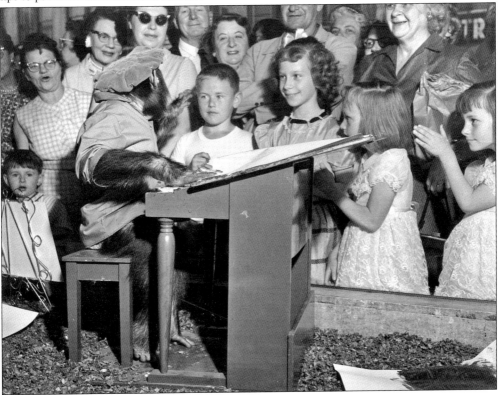

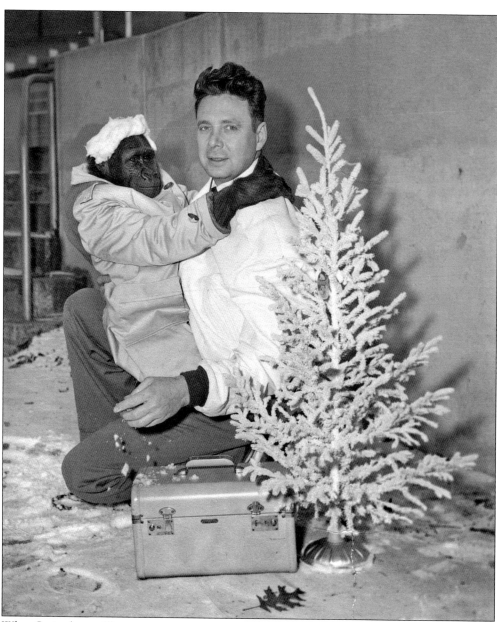

What Susie the gorilla was to entertainment in the 1930s and 1940s, the diminutive Penelope was to gorilla breeding and species survival, setting a world record in 1974 for lowland gorilla births in captivity with four offspring. Zoo veterinarian Byron Bernard, shown here in an undated photograph with Penelope, received the orphaned three-year-old in 1957 from her adoptive owner Dr. Albert Schweitzer. The humanitarian/missionary needed a supply of fresh milk for patients dying because of calcium deficiency at his medical mission in the jungles of French Equatorial Africa in Lambarene. A campaign was begun in Cincinnati, "Goats for Schweitzer," and Bernard traveled thousands of miles with Cathryn Hosea Hilker, known for her subsequent work with cheetahs, to deliver a four-wheel drive Studebaker truckload of 15 Nubian goats and $20,000 in medical supplies, part of a gift from Fred Knoop of the American Dairy Goat Association. Penelope was a thank-you gift.

Penelope lived with veterinarian Byron Bernard's family for almost three years in Park Hills, Kentucky. "She was like a child," he said in a *Cincinnati Enquirer* interview in 1989. "She ate with us every night. She went to bed on time. She drank her bottle of beer." (Well, she was almost like a child.) The young ape liked taking bubble baths and riding in Bernard's convertible. One of his oft-told stories recounted a convertible ride with Penelope, who liked to wear lady's hats. A driver who pulled up next to them at a red light glanced over to see a gorilla and, shocked, drove through the light.

An undated Christmas card photograph shows Penelope and one of Bernard's sons playing a bongo drum. A Bernard daughter, Babette, is shown in the 1970 photograph below holding Penelope's first-born, Samantha.

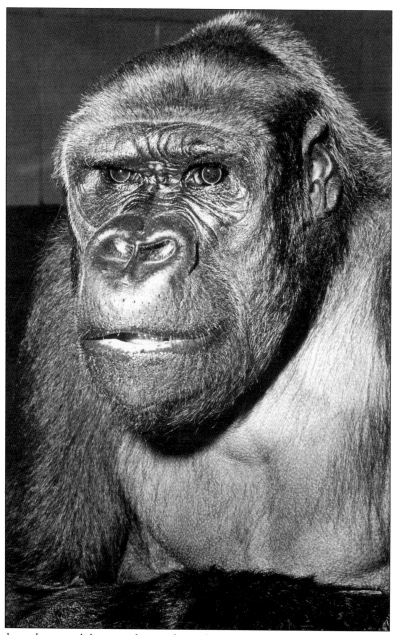

Many apes brought up with humans from infancy do not easily socialize with other apes. Penelope was an exception. Though described as a "loner" in relationships and known to have rejected a prospective mate M'golo's advances (who had batted her around when they were youngsters), Penelope mated successfully with crowd-favorite King Tut. Penelope played a starring role in the baby gorilla craze that began in 1970 when Tut and Penelope became parents of Samantha, and Hatari and Mahari became parents of Sam eight days earlier. Penelope became the first gorilla in the world to give birth to four offspring in captivity. She died on May 3, 1989, at the age of 35, the same day a granddaughter, and namesake Penelope II, was born. There was some thought the ape died of a brain tumor. Later veterinarian Byron Bernard insisted that Penelope was actually about five years older than everyone thought.

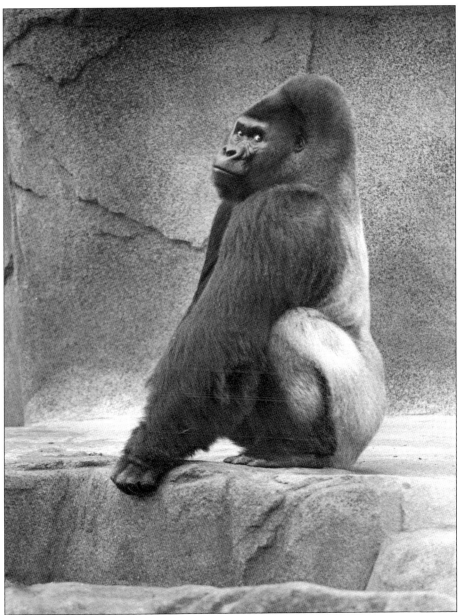

King Tut only had eyes for the red-head Penelope. Born in the wild, the magnificent silverback who caused other apes to scatter when he lumbered into the exhibit, sired four surviving gorillas. Early on, a bout with wasting illness had fans grieving until it was discovered Tut had a wheat allergy. After a diet change, the bruiser tipped the scales at 475. Tut was part of the family that opened the $4 million Gorilla World in 1978 and did his duty to set the record for gorillas born in captivity. Tut died at 38, about 60 in human years, after a second round of dental surgery to repair bad molars. Heart-broken Cincinnatians rallied to keep Tut in Cincinnati even though a deal had been brokered to make the mounted specimen part of an exhibit at the Natural History Museum of Los Angeles County. But scientific heads prevailed and instead a plaque was placed at the entry of the Primate Center. "He was gentle. He liked everyone except veterinarians," said Ed Maruska, zoo director at the time. (Photograph by Janet Ross.)

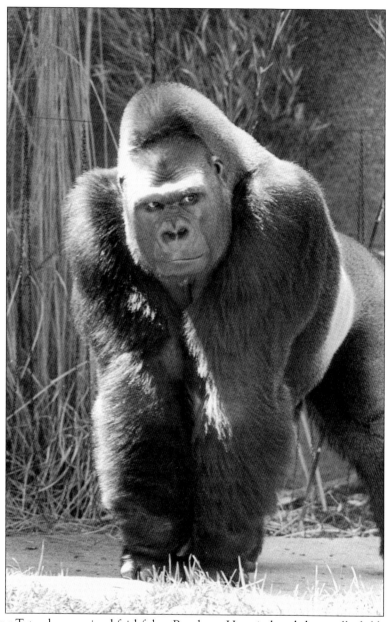

Unlike King Tut, who remained faithful to Penelope, Hatari played the gorilla field in the zoo's mating dance in the 1970s and 1980s, fathering four babies with Mahari (plus two that died), one with Magara, and one with Samantha. He even fathered a baby with Penelope, but it died the day it was born. But the musical-chair mating was all in the interest of propagating and preserving the lowland gorilla, endangered due to habitat destruction from logging, agricultural expansion, and the bush meat trade. Donated in 1965 and from the wild, Hatari was believed to be about four years old at the time. In 1978, he broke a tooth roughhousing with the other gorillas and made news during his resulting root canal procedure. Dr. John M. Schulter used a quick-set filler paste, but it was not quite quick enough. As the procedure was wrapping up, Hatari stirred and grabbed the ankle of one of the surprised attendants before more anesthesia was administered. Hatari was transferred to the Chapultepec Park Zoo near Mexico City and died on August 12, 1990.

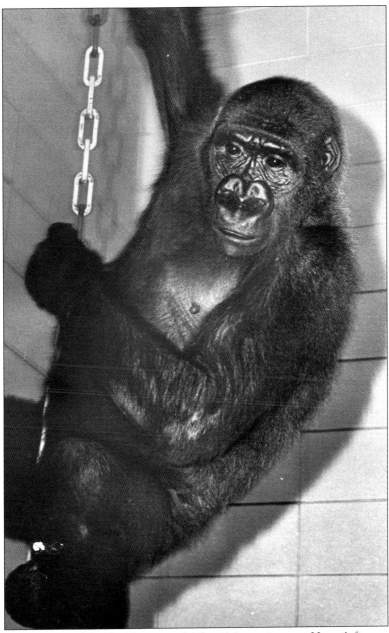

Wild-born Mahari, named for the Tanzanian Mahari Mountains, was Hatari's first mate and the matriarch of one of the zoo's two most fruitful gorilla families, giving birth to six babies, four of which survived. But motherhood did not come naturally to Mahari. Estimated at about three years old on her arrival in 1965, Mahari did not get the hang of motherhood at first. Sam, the much-celebrated first offspring in 1970, had to be hand raised. The second, Kamari, a female, fared a bit better but had to be taken away after about three months. By the time the third offspring, Amani (a female), came, Mahari was able to keep her for nine months until medical treatment was required. The fourth, Mata Hari, a female, remained with her for two and a half years. Mahari went to the Chapultepec Park Zoo near Mexico City and died on November 14, 2002. (Photograph by James F. Brown.)

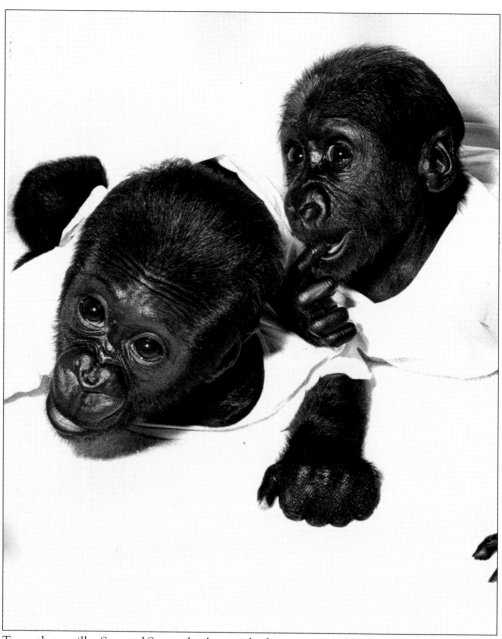

To say that gorillas Sam and Samantha, born eight days apart in 1970, on January 23 and January 31, respectively, were media sweethearts is an understatement. Their photographs were everywhere as they cuddled and snuggled, then wrestled and tumbled together in the nursery where they stayed, unable to be nurtured by their mothers. Both from wild-born parents (Hatari and Mahari were Sam's parents; King Tut and Penelope were Samantha's parents), they were a welcome addition to the gene pool of endangered western lowland gorillas. Sam went to the Stone Zoo in Stoneham, Massachusetts, and died at the Knoxville Zoo of heart disease after failing to wake up after anesthesia on November 17, 2000. Sam fathered Quito and Kubandu. Samantha, still a Cincinnati zoo favorite, bore six offspring, three with Hatari, two with Babec, and one with Chaka, plus a stillborn birth by Jomo in 2006. (Photograph by Julianne Warren.)

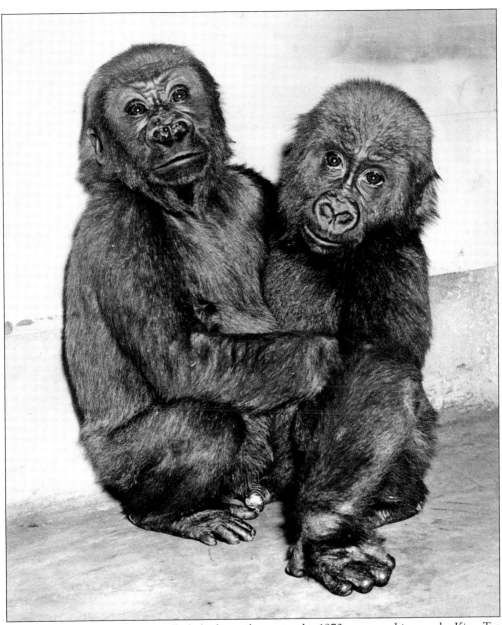

Even before the Cincinnati gorilla baby boom began in the 1970s, powered in part by King Tut (pictured here shortly after his arrival in 1952 with another youngster, Sheba), baby gorillas were irresistible to visitors and photographers. Within 15 years, King Tut grew into a fearsome-looking silverback and one of the cornerstones, with mate the red-headed Penelope, of the Cincinnati breeding program. The first registered gorilla birth in captivity took place on December 22, 1956, at the Columbus Zoological Garden. But Cincinnati is one of the leading zoos in captive gorilla births, closing in on 50. And it holds the record for most gorilla births in one year, with six in 1996. The zoo partnered in the first test-tube gorilla birth, when Mata Hari/Rosie's eggs were fertilized with sperm from a gorilla at the Henry Doorly Zoo in Omaha, and she gave birth in 1995 to Timu, a female. Sheba, the baby pictured with King Tut, lived 20 years in Cincinnati and died in January 1972 of liver degeneration.

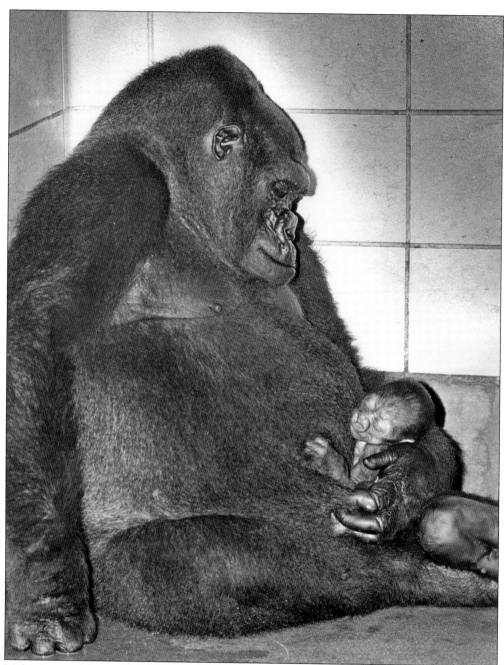

Mahari, one of the two mothers powering the gorilla baby boom in the 1970s, is shown in this photograph cuddling Mata Hari, born August 1974, her fourth baby and the one offspring Mahari was able to successfully tend to the longest, keeping her close by for two and a half years. Previous offspring had to be cared for in the nursery. Mata Hari, also known as Rosie, took mothering in stride, however, and gave birth to the first test-tube gorilla Timu, a female, in 1995. Years later, in 2005, when Timu subsequently faltered in child-care duties a few hours after giving birth to her second baby, Mata Hari/Rosie made further advances in motherhood by helping care for the infant, a granddaughter, according to news stories.

Six

FUN AND GAMES

As early as 1876, zoo bigwigs knew that animals alone could not keep the turnstiles whirling. So began the delicate balancing act between entertainment and animals.

Balloon ascensions were one of the first big "extras" in the zoo's earliest years. A July 1876 ascension gone awry was recounted in a 1966 *New Yorker* magazine by a writer recalling a grandfather's youth. A balloon ascension from the zoo ended rather abruptly on a sandbar where the grandfather and his friends were skinny-dipping in the Ohio River near Dayton, Kentucky.

"I looked up and saw a huge silver balloon with ribbons floating around the basket drifting downward . . . it landed in a foot or two of water . . . and a lion jumped out, about the size of a large police dog and as the poor thing started to trot off . . . I picked it up and petted it to soothe it."

Fireworks were also a big draw, as well as dancing and live music. Along with lions, tigers, and bears, visitors saw acrobats, aerialists, and Shakespearean players. "Military" elephants drummed up patriotism. There were mini-expositions touting new household products, leading to the annual Food and Home Show. Lifestyles in exotic lands were showcased. There were tugs-of-war between elephants and humans, the Zoo Opera, and even butchering contests. Today's Festival of Lights, Zoo Babies, and Zoo Blooms continue to be touchstones in people's lives.

The first rides were on elephants and horses. But by the early 1900s, a hand-carved carousel was purchased for $11,000 from Gustav Dentzel of Philadelphia. It was replaced by a larger carousel in 1918 from the Philadelphia Toboggan Company that is preserved at Woodland Park Zoo in Seattle, Washington.

In the 1920s, a summer ice-skating rink was added, followed by a succession of rides added every year. The trend ended in the 1970s, when the carousel was the first to go to make room for Gorilla World and the Peacock Pavilion. But in a throwback to nostalgia, a Chance Morgan carousel was added in 2003 with 30 animal figures, including a cheetah, an okapi, rhinoceros, an ostrich, and others.

JOHN ROBINSON'S MILITARY ELEPHANTS

In the tough economic times of 1916, John G. Robinson had to sell his circus, which wintered in Terrace Park. Eventually it ended up with the Ringling Brothers Circus. But he kept four elephants, including Tillie, the circus's first elephant in 1872, who famously subdued the crazed Chief (from chapter three, Crowd Favorites and News Makers) by sitting on the runaway pachyderm. Robinson created a traveling Military Elephant Show that occasionally performed at the zoo as well as in vaudeville. Terrace Park children during those years were treated to impromptu elephant shows on the Robinson's grounds on Circus Place. According to newspaper reports, the elephants would "dash about in military garb, maneuver and fire cannons under the direction of Capt. George Thompson, pictured here. "One would fall wounded, and Tillie, wearing a Red Cross nurse's cap, would rush to the scene." Tillie hung up the nurse's cap in 1926 and went to the zoo in 1930, where she died in 1932. A public funeral was held in Terrace Park, and school was canceled for a public pageant and funeral.

These handout cards touted the zoo as "instructive and amusing to young and old." The original admission, 25¢ for adults and 15¢ for children under 10 (soon lowered to 10¢), stayed the same until 1958. Though it sounds like a bargain now, many people made barely $50 a month then.

DONT FAIL TO VISIT
The Zoological Gardens
one of the largest collections of rare Animals in the World

45 ACRES OF BEAUTIFULLY CULTIVATED LANDSCAPES

INSTRUCTIVE AND AMUSING
TO YOUNG AND OLD

Open daily from 8 A. M. to 10 P. M.
Take Vine Street or Mount Auburn Cable car

Admission 25 cents
Children 10 »

A 1937 letter sent from Henry Hyamus, then 75, recalls his trip as a 14 year old. "My cousin and I walked from the East End . . . in October 1875. We had a total capital of 35 cents so my cousin asked the ticket-seller if we could both get in for a quarter. They allowed us in. We had 10 cents left and bought a bag of peanuts and divided them up with the monkeys. We walked all the way home, five miles, tired but very happy."

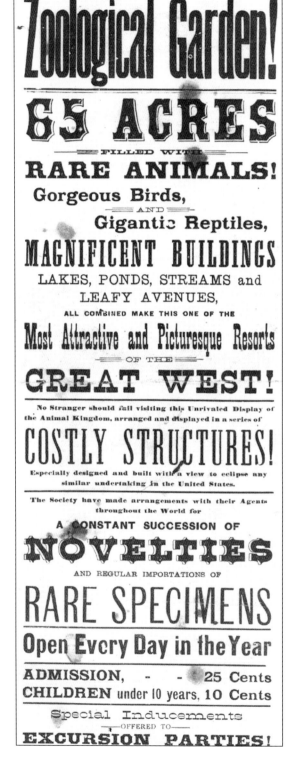

This advertisement from the zoo's early days brags of "gigantic reptiles," "magnificent buildings," and "one of the most attractive and picturesque resorts of the great west" in the advertising hyperbole of the day. And though the opening day in 1875 left much to be desired, with unfinished exhibits and animals still being delivered, by the end of the year, the collection of animals was "respectable" for those days, with nearly 800 specimens, including what newspapers like to call "wild beasts" and "heavy-biters." It included 11 bears (including 2 grizzlies and 2 polar bears), 6 lions, 2 tigers, 1 leopard, 1 wild cat, 1 puma, 3 hyenas, and 1 bush cat. Other animals listed in the annual report: 1 wolf, 6 foxes, 13 dogs, 9 Shetland ponies, 4 llamas, 2 camels, 13 kinds of monkeys, 5 deer species, 3 kangaroo species, 2 alligators, 3 bison, 58 prairie dogs, 1 elephant, and 84 species of birds. Receipts were listed as $161,787.51, with expenses at $161,665.09, leaving $122.42 "cash on hand."

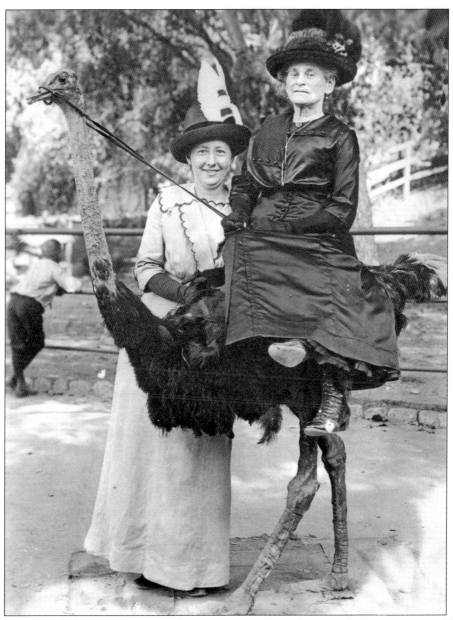

These unidentified early-20th-century ladies are not riding a live ostrich. It is not impossible to ride a live specimen, though it is considered an "extreme" sport at ostrich farms today because of their sharp claws and potent forward kick. One could never sit so far forward, and so placidly, on a live ostrich. Being photographed with, or on, a mounted exotic animal was often a feature of zoos and animal farms around 1900 when taxidermy was quite popular. In the 1890s and early 1900s, the art and popularity of taxidermy was illustrated by the large numbers of mounted animals at the zoo, most in the Carnivora House, where crowd favorites were often displayed after death. A 1900 book, *Studies in Zoology: A Book Devoted to the Animals and Animal Life at the Cincinnati Zoological Garden*, described a group of mounted lions above the entrances, the only baby giraffe born in America, an 18-foot tall giraffe, and Chief, the rogue bull elephant who had to be killed in 1890.

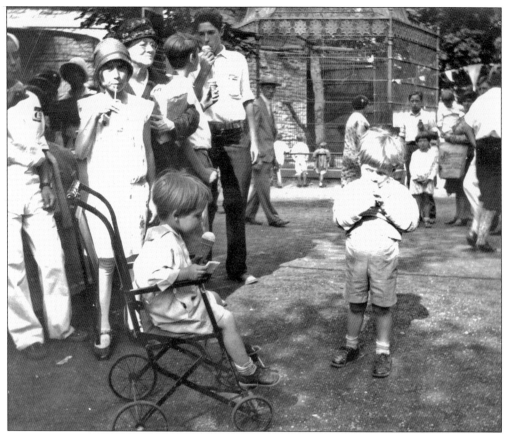

Ice cream and beer, enjoyed separately one presumes, have been food and fun staples at the zoo since its early days, as shown in this photograph from the 1930s. The original Clubhouse and Restaurant staged sumptuous banquets with French cuisine at its several restaurants for Cincinnati movers and shakers, as well as family dining and a la carte items, before it was razed in 1937. When the zoo Clubhouse and Restaurant was under the management of Carl Mecklenburg, son of Mecklenburg Gardens' restaurant owner Louis, the Lower Porch menu, shown at left, listed fare in keeping with the garden's German heritage but strange by today's visitor standards: sardines, 40¢ per box; beef tongue, 50¢; fried egg sandwich, 15¢; homemade pie, 10¢; and the still-favorite hot frankfurter (with potato salad), 40¢.

Great Beef=Killing Contest

Of the German Butchers' Society, of Hamilton
County, O., will take place at the

ZOO, Thursday, September 1, 1898,

At 4 p. m., Sharp.

AMERICAN RULES GOVERNING BEEF KILLING CONTESTS.

1. Cattle shall weigh no less than fourteen hundred (1,400) pounds, alive, and shall be free from brands, and must have no feed for thirty (30) hours preceding the contest, but must have plenty of water.
2. There shall be three (3) judges, who shall be considered honorable men and thoroughly acquainted with the dressing of beef, also three (3) official time keepers.
3. Helper's duties: "Knock" the bullock; "bleed;" skin head properly; pritch up bullock; skin both forefeet properly; raise windpipe or gullet; skin out paunch leg or right hind leg, to gamble joint, properly; open bullock; saw or split brisket and crotch. Helper shall be careful not to infringe on dresser's points in doing work. If he does, points shall be taken off dresser's tabs accordingly. Helper shall put beef tree or hooks in position; helper to empty bullock and mark kidneys; helper to assist dresser in handling tools, and to beat out fells if necessary.
4. When helper has bullock prepared for dresser, and dresser declares himself ready, judges shall allow ten (10) seconds to prepare before call of time.
5. Points to be considered as follows, viz:
 1. Fifteen (15) points for opening, rimming and siding bullock.
 2. Five (5) points for legging.
 3. Fifteen (15) points for rumping and backing.
 4. Fifteen (15) points for splitting.
 5. Ten (10) points for clearing shank and dropping hide.
 6. Twenty (20) points for time of eight minutes.
 7. Ten (10) points for general neatness.
 8. Ten (10) points for condition of hide.

This constituting the one hundred (100) points to credit, contestants will be allowed eight minutes to dress the bullock in.

The following points will be deducted for the following defects:
Twenty (20) points off for every minute over the allotted time and ten (10) points allotted in his favor for every minute less, dresser to call time when finished, and he will not be allowed near carcass or hide "till judges have made inspection."

6. Should contestants appear before the judges in an intoxicated condition, cutting hide or carcass in a reckless manner, judges shall have power to remove said person, and allow competent man to finish.

Following are the prizes to be given away in this contest:
First prize, $150; second prize, $75 and third prize, $25.

Grand exhibition of sheep killing, by Walter Fisher, immediately after beef contest, after which winner will be announced.

(over)

Beef-killing contests, in keeping with Cincinnati's butchering and pork-centered past, were popular events, sometimes drawing 1,000 people, "including the gentler sex," according to one 1890 report. The zoo hosted the Great Beef-Killing Contest in 1898, publicized by this flyer explaining the rules and judging criteria. In the contest, sponsored by the German Butchers' Society of Hamilton County, live cattle, weighing no less than 1,400 pounds, were brought to the stage and dispatched, usually with an ax. After the head and feet were removed and the steer prepped by a "helper," time was called, and a "dresser" set to work earning points for speed, neatness, condition of the hide and other fine butchering practices. First prize was $150, second was $75, and third was $25. At the grand competition in New York City's Central Park in 1890 the prize was $1,000, and the winning time was 4 minutes, 22 seconds. For diehard fans, the cattle dressing was followed by a sheep-killing event.

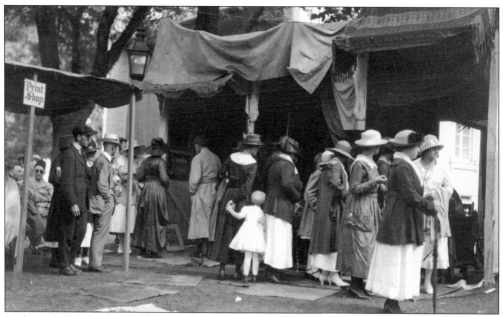

In the early 1900s, almost 30 years after the zoo opened, people were hungry for information and exposure to the world beyond Cincinnati. To satisfy this curiosity and to keep visitors streaming through the gates, the zoo hosted bazaars and mini-expositions focused on faraway lands. Tents manned by costumed exhibitors displayed musical instruments, fabrics, jewelry, clothing, and foods for each country or region.

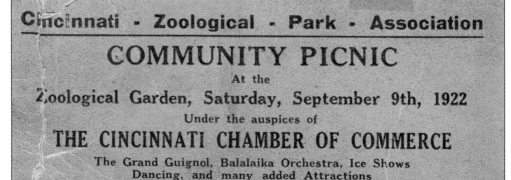

Picnic grounds, near the location of today's Giraffe Ridge, were a shady respite for families and groups. This ticket to a 1922 community picnic promises the Balaika Orchestra, ice shows, dancing, and Grand Guignol, or short, macabre plays. And who knew ticket scalping was a problem then? The small print reads, "this ticket will not be honored if sold or given away within 1,000 feet of the entrance."

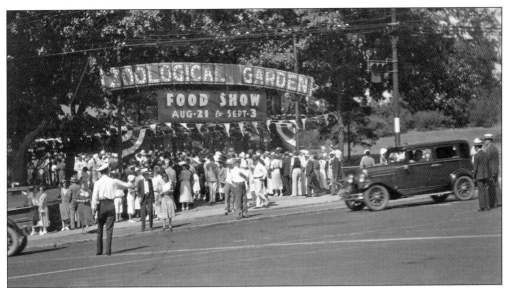

One of the most successful non-animal events at the zoo was the annual 12- to 14-day Food and Home Show that ran from 1918 to 1969. Originally the Pure Food Show, it was called the "most successful event of its kind in America" by the president of the National Retail Grocers Association in the 1950s. More than 150 booths lined the walkways from the entrance, shown in a 1934 photograph above, around Swan Lake, today's Reptile House down to Gorilla World. Over 150,000 people turned out each year for food samples, grocery, appliance and cleaning product giveaways, and food preparation demonstrations in the pavilion, shown below in the 1955 photograph. Through the years, it grew to include fashion shows, baby beauty and baking contests, entertainment by country western acts, bingo, quiz shows, and, of course, performances by chimpanzees and sea lions.

Rides for children at the zoo began with elephant and pony rides at the Pony Track, located near today's Safari Camp. The carousel arrival in 1902, and its expansion in 1918 introduced mechanical rides that soon took center stage, growing into Playland, with a new ride introduced every spring, including the mini automobiles shown above that could be "driven" by children with instructors in the 1950s. But even as late at 1960, children still lined up to ride "live" animals, though Slow Poke, a 200-pound tortoise from the Galapagos Islands, could hardly be described as a wild ride even for then four-year-old Cindy Summers. In 2003, the carousel returned with a Chance Morgan design that was 36 feet in diameter, and included chariots, okapi, white rhino, a manatee, a cheetah, an ostrich, and more for a total of 30 zoo animals.

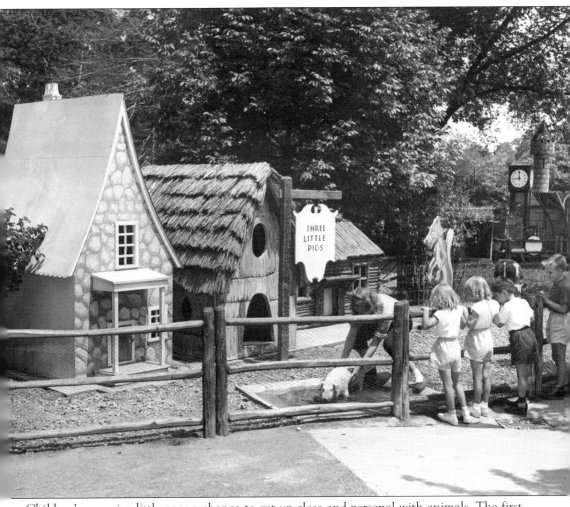

Children's zoos give little ones a chance to get up-close and personal with animals. The first children's zoo in Cincinnati was built after the razing of the Clubhouse and Restaurant in 1937 and has been expanded and improved several times. The 1964 renovation was in memory of Powel Crosley Jr., the radio whiz and businessman who once donated six polar bears captured in the Arctic in 1934. A second renovation, costing $2 million, opened in 1985, made possible by Ruth Spaulding, in memory of her husband and son. Children can feed goats, pet many animals, climb on a spider web, howl with the wolves, and get closer to animals, as shown in this photograph from the 1950s.

Today's Safari Train has gone through several variations. The first miniature railroad in the 1940s was expanded and relocated in 1959. A trackless diesel-powered tractor train that could hold 48 passengers and go 15 miles per hour was added in 1951, costing $8,000. A 25-foot-high trestle was built over the African Veldt, and at one time, there were three trains: Swan Lake Special, Bear Pit Train, and Buffalo Express.

The Festival of Lights is the modern touchstone and tradition for today's visitors and one that executive director Thane Maynard says people mention most often. From Thanksgiving to January 3, more than 2 million lights are strung throughout the zoo, and the switch is thrown every night at 5:00 p.m. Cold-weather animal attractions, like polar bears, seals, snow leopards, and tigers, are supplemented by puppet shows, caroling, and ice-carving. (Photograph by Dave Jenike.)

Seven

THEN AND NOW

Today's Cincinnati Zoo is a different animal from the ragtag collection of 769 specimens on display in 1875. Now there are roughly 1,800. Even the name is different. Incorporated as the Cincinnati Zoological Garden, today's name, the Cincinnati Zoo and Botanical Garden, reflects the 3,000 species of plants and the emphasis on horticulture.

Little about the grounds is the same except two original buildings and the remnants of the first footprint. The original 64 acres has grown to 85. The street intersection, once Carthage Pike and Albany Avenue, is now Vine Street and Erkenbrecher Avenue. People arrived then by foot, horse and buggy, or streetcar, not by cars.

The first guidebook was printed in German. Now virtual visitors can watch online videos of zoo favorites or see 4-D Special FX movies at the park. In 1875, expenses totaled $161,655. Now the operating annual budget is $24.5 million. Then animals were trapped and sold by dealers or brought back by travelers. Now most are loaned or moved according to Species Survival Plan guidelines.

Begun like most zoos of the day to wow visitors who had never seen a grizzly bear or a kangaroo, the zoo morphed into an entertainment venue with a sometimes shameful sideshow quality as administrators experimented and learned, along with visitors, to appreciate their charges for their nature rather than their spotlight performances.

In short, the zoo grew up. There is still a lion and an elephant, an ostrich, a camel, a tiger, bears, and the "heavy-biters" described in the opening-day menagerie. But today's lions and bears lounge in canyons and swim in plunge pools. Elephants live in family groups and bathe in waterfalls, as they do in the wild. Gorillas climb and swing in trees. They romp in a close approximation of their natural environment, interact naturally, and reproduce, sometimes with the help of technology.

Animal husbandry is a science now, not an experiment. And species survival is paramount.

Education and conservation are cornerstones as zoos take the responsibility to teach all that humanity can damage or preserve the world and the plants and animals in it.

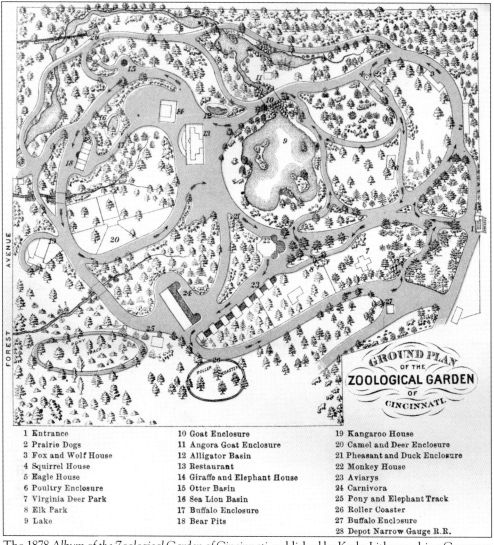

1 Entrance	10 Goat Enclosure	19 Kangaroo House
2 Prairie Dogs	11 Angora Goat Enclosure	20 Camel and Deer Enclosure
3 Fox and Wolf House	12 Alligator Basin	21 Pheasant and Duck Enclosure
4 Squirrel House	13 Restaurant	22 Monkey House
5 Eagle House	14 Giraffe and Elephant House	23 Aviarys
6 Poultry Enclosure	15 Otter Basin	24 Carnivora
7 Virginia Deer Park	16 Sea Lion Basin	25 Pony and Elephant Track
8 Elk Park	17 Buffalo Enclosure	26 Roller Coaster
9 Lake	18 Bear Pits	27 Buffalo Enclosure
		28 Depot Narrow Gauge R.R.

The 1878 *Album of the Zoological Garden of Cincinnati,* published by Krebs Lithographing Company of Cincinnati, included this fold-out map of the zoo grounds. The entrance, which moved east when automobiles had to be accommodated, is now approximately in the same area as the original gate, though much higher in elevation. The Cincinnati Northern, a narrow-gauge railroad, provided service to the Forest Avenue northern edge of the grounds. The map also shows a roller coaster near today's World of Insects, though no historical reference to it could be found. The layout of the original plan by landscape gardener and engineer Theodor Findeisen can still be seen in today's map. His work was considered a masterpiece and was similar to curving, circular layouts in zoological parks in German gardens, with an outer belt connected by walkways and paths.

Today's zoo has the same general footprint as the original property, hemmed in by Erkenbrecher Avenue, Dury Avenue, Forest Avenue, and Vine Street. The many streams along the north and eastern edges of the original land were altered or dammed up so that today's Swan Lake and water surrounding Gibbon Island remain the only waterways. The 66.4 acres, "more or less," as described in the original lease, was trimmed by 21.3 acres in 1886 to solve financial problems, but later land purchases brought the total back up to 67 acres, then to 85 with parking lots. Today's Reptile House is the only original zoo building that survives in the same location. The Passenger Pigeon Memorial is an original building, but it was moved from its first location, near today's Gorilla World.

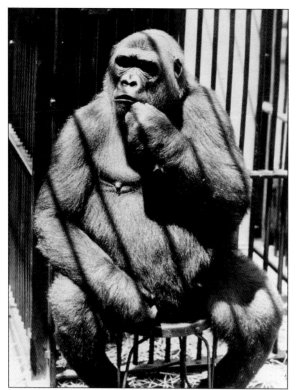

During her tenure in the 1930s and 1940s, the accommodations of Susie, "the world's first trained gorilla," were a sometimes damp, barred indoor cage behind glass, an outdoor cage in good weather, and a hammock. Her official owner, R. J. Sullivan, wrote a letter to the board from Susie's standpoint: "Why not say 'come and see me locked up in a glass bandbox where the children can see me suffering from the heat.'"

A little over 30 years after Susie died, the zoo's western lowland gorillas found themselves in a very different world for captive animals; they were surrounded by vegetation, rock outcroppings, waterfalls, climbing trees, and bushes in a 5,500-square-foot exhibit built to simulate their natural surroundings. Visitors can observe the family groups across a deep moat, from which a mist occasionally rises, providing an eerily authentic air.

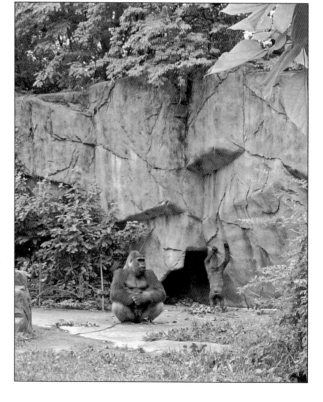

The original bear pits were built on a hillside suggesting their mountainous habitats. At today's zoo, this would be at the lower end of the polar bear exhibit. The 78-foot-long stone building was divided into three, 12-foot-deep pits, with the polar bear in the center compartment, measuring 22-by-24 feet wide with curved bar front, a watering hole, and two 4-by-6-foot dens tucked into the sides.

Today's Lords of the Arctic exhibit is three times the size of the expanded bear grotto built in the 1930s. A recent renovation made of shotcrete, a concrete material that can withstand the bear's claws, includes four waterfalls, a "children's" cave to replicate a den, a 70,000-gallon pool, and a 12-foot-deep diving pool with aquarium viewing from the side.

Entrance Zoological Gardens, Cincinnati, Ohio.

The zoo's main entry went though several variations by architect James McLaughlin, starting out as sketches of a small building with a scalloped roofline, three ticket windows, and a stove, to the final entry, shown in this early photograph, with two turnstiles connecting the ticket window structure, at left, to an auxiliary building.

The newest entry, opened in May 2009, is in the same spot as the original after being relocated decades ago to Dury Avenue to accommodate automobile parking. Called Vine Street Village, it retains the early-20th-century turnstile entry but sits two to three stories higher in elevation than the original street-level structure.

The original Eagle House, built in 1887 and designed by Gustav W. Drach, was considered cutting edge at the time, with a central dome 45 feet high and a length of 90 feet. One of the largest free-flight cages at the time, it had seven compartments for eagles, vultures, hawks, and owls. But by 1947, a newspaper article criticized its upkeep and age, calling it "old-fashioned and inartistic."

Eagle House, Zoological Gardens, Cincinnati, Ohio.

Today's Eagle Eyrie is built on the site of the 1880s Elk Park near the string of stone Aviaries. The flight cage opened in 1970 is 72 feet high, 140 feet long, 50 feet wide, and can be viewed from a platform inside the cage or from the outside and below along Wildlife Canyon.

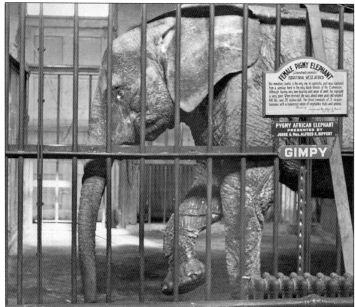

Conqueror, the zoo's first elephant, showed displeasure with his quarters by tearing down the bark and branches that covered the walls of the original Buffalo House. Later elephants, including Gimpy the pygmy elephant of the 1930s, shown in this undated photograph, were housed in the Herbivora Building in barred cages with limited outdoor access.

Today's Asian elephants still live in the Herbivora Building, but their newly expanded quarters, the Marge Schott–Unnewehr Asian Elephant Reserve, is the zoo's largest exhibit, at 4 acres, and includes spacious outside elephant yards with waterfalls, a 60,000-gallon pool, and a separate yard for the bull elephant. Daily baths (they usually get two) are open to the public in warm weather and are a favorite attraction.

Giraffes were usually kept in the Herbivora Building after it was built in 1906 but behind high fencing with occasional access to the outdoors. Alice, the female giraffe named after one of Pres. Teddy Roosevelt's children, successfully delivered a baby, shown here about 1910. Alice died of fright during a thunderstorm eight months later.

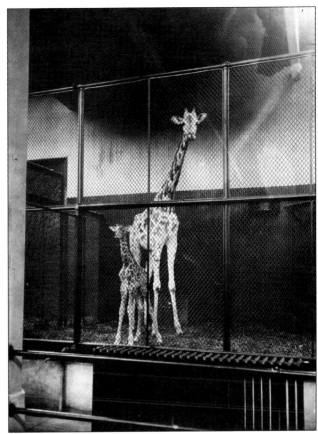

The Maasai giraffe are eye-level with visitors to Dobsa Giraffe Ridge, opened in 2008. The $1.6 million exhibit, with 27,000 square feet of space and an elevated viewing platform, puts visitors close enough to hand-feed the lanky giants, equipped with 18-inch-long tongues. The decking is made of recycled plastic and wood waste, and the 2,500-square-foot barn's green roof is covered with plants to absorb rainwater.

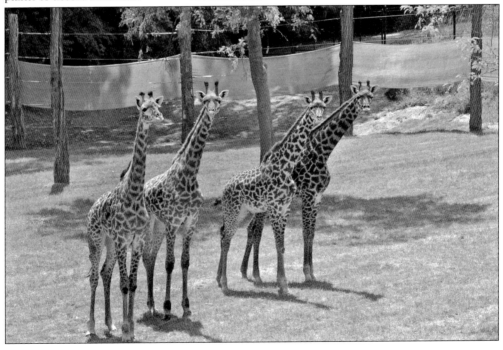

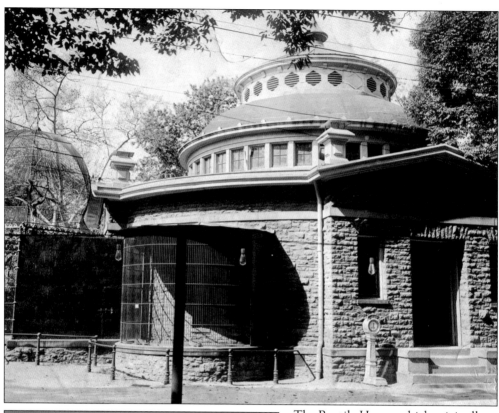

The Reptile House, which originally housed monkeys, is the oldest existing zoo building in its original location, although it was slated for demolition in the 1960s. The 1947 *Cincinnati Enquirer* article in which this photograph appeared called it a "museum piece . . . unsanitary . . . with poor visibility." But in 1975, it was put on the National Register of Historic Places.

Lush plantings surrounding today's Reptile House reflect Cincinnati Parks superintendent Adolph Strauch's 1873 wish to establish both a garden and a zoo. The 1987 name change, to Cincinnati Zoo and Botanical Garden, marked the evolution of the botanical collection from formal gardens to plants tied to the origins of the exhibits and native species. More than 3,000 kinds of plants, extensive labeling, and seasonal displays make it a green-thumb favorite.

Eight

ENSURING A FUTURE

Conservation and education have been in the spotlight, perhaps unwittingly, since the zoo's opening months in 1875 when three American bison were added to the collection of 769 animals. Though the goal of early zoos was to satisfy the public's interest in animals from exotic locales, a native species qualified by being in danger of extinction. And that was certainly the case of the bison, or buffalo, whose thundering numbers quieted to a few hundred by the mid-1880s. With more Americans living in cities at the time, interest was rampant in the remnants of the Wild West. Exhibiting bison was a triple-play: education, entertainment, and conservation.

The zoo has been combining those three ever since. Zoo trees were labeled as early as 1894; public schools began sending students to the zoo twice a year to study animals in 1896. Zoo legend Sol Stephan was ahead of his time in his eagerness to trade animals for genetic diversity and to secure animals dwindling in the wild, including the Przewalski's horse, the dwarf donkey, and the ill-fated passenger pigeon.

In 1955, entertainment began to take its eventual back-seat perspective in zoo life when then-president E. W. Townsley wrote in the annual report, "zoos must give more consideration to the code of objectives and fight more vigorously for the cause of wildlife protection."

Since then, the zoo has made many advances, aided by science and like-minded organizations, including the International Species Inventory System (ISIS), a data bank that manages the transfer of animals for breeding loans and sales, and initiatives such as the Species Survival Plan, which has made major advances in carrying this out.

Research at the Lindner Center for Conservation and Research of Endangered Wildlife (CREW), founded in 1986, has made the zoo an international leader in the protection and propagation of endangered animals and plants through cross-species embryo transplants, in vitro fertilization, and cryogenics research. And the SCaRCE Cat Canyon/Small Cat Reproduction Center will establish the first dedicated breeding facility for endangered small cats at any North American zoo.

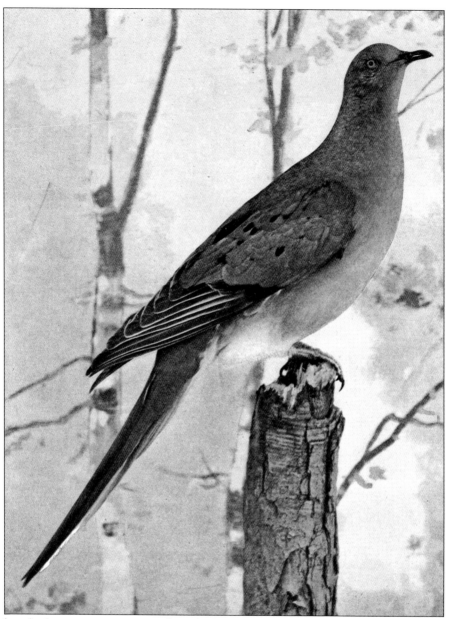

Martha, the last passenger pigeon alive, died on September 1, 1914. But the birds were once ubiquitous. People told of seeing flocks in the billions, a mile wide and 300 miles long, so large in Ohio, Kentucky, and Indiana that the sky was darkened for hours as they passed. Called passenger pigeons because they were always on the move, they were twice the size of a mourning dove with gray and blue coloring and iridescent specks. When cheap pigeon meat became popular for slaves and the poor in the 19th century, they were hunted on a massive scale, first with nets and then with new, improved breech-loading shotguns in the 1850s. Their numbers plummeted between 1870 and 1890 as laws to protect them were stymied. Those not sold for food, at a penny each, were fed to hogs, used as fertilizer, and even buried in ditches. Trappers averaged 250 birds daily, and one report from Michigan in 1878 tallied as many as 50,000 killed daily, for months. The Audubon Society unsuccessfully offered $1,500 for a mate for Martha, named after Martha Washington.

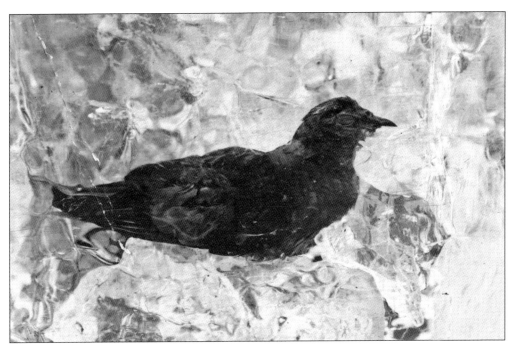

Martha's age at death was estimated from 17 to 29 years, though doves have a normal lifespan of 7 to 15 years. Sol Stephan's handwritten notes do not help: some say she was hatched from the purchase of four pair or from three pair that were captured in 1878. Another says Martha was purchased in 1902. After death, she was frozen in a 300-pound block of ice and shipped to the Smithsonian Institution for display.

When the outdoor gorilla exhibit was being built in the 1970s, the original Aviaries, then being used for monkeys, were demolished, with one exception. The pagoda-style building where the last passenger pigeon and Carolina parakeet lived was refurbished in their honor and opened on September 1, 1977, sixty-three years to the day Martha died. Mounted Martha made a trip from Washington for the event.

The only native parrot in the United States, the Carolina parakeet did not number in the billions like the passenger pigeon, but it was prodigious, flying wild from the Great Lakes to the Gulf Coast. The brilliantly colored green-and-yellow birds with red faces did not migrate and were able to withstand harsh winters. Farmers took aim at them because of crop damage, and hat-makers prized the feathers. But the parakeets did not help themselves. Instead of flying away at the sound of a gun, they would often return to the sound's source "to help" distressed friends. Disease contracted from poultry and deforestation also had helping hands in their decline. The last wild flock was seen in 1904, and the last bird, Incas, died at the zoo in 1918, a year after his mate, Lady Jane. The pair was at the zoo 32 years, according to the *Cincinnati Times-Star*, and general manager Sol Stephan refused offers of $400 for them. Incas's body was intended to go to the Smithsonian Institute but was "lost in transit." (Illustration by John A. Ruthven, www.ruthven.com.)

In 1923, the zoo's dwarf donkey, Daisy, gave birth to a baby, the first born in America, weighing in at 16 pounds, knee-high at 21 inches tall with 9-inch ears, and grey in color. This photograph, taken when the newborn was two days old, shows the diminutive stature of the adults as well, which averaged about 29 inches and weighed about 165 pounds. The newspaper article said the donkeys would be used at the Pony Track "on very special occasions" and that general manager Sol Stephan intended to "raise a herd of them as they are rapidly becoming extinct" in India, where they could still be found in the wild at the time. In the wild, they ran in herds of 20 to 40 animals. As captives they were sometimes used to turn grinding stones for grain and to carry water from wells.

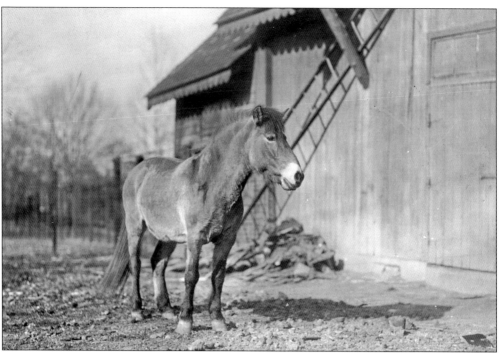

Now on the critically endangered list, the Mongolian Przewalski's (sheh-VAL-skeez) horse was special in the early 1900s because of its rarity in captivity. The Cincinnati Zoo was the first U.S. zoo to exhibit them in 1905, shown in the above photograph, part of 14 captured by German animal dealer Carl Hagenbeck that became the gene pool for all in captivity today. Zoo manager Sol Stephan once told the story of trying to ship one of the notoriously hard to domesticate animals to the Washington Zoo in a crate specifically sized to restrict the horse's movement to prevent injury. When the crate was opened, the horse was found upside down "having managed a complete a somersault." American zoos were the first to create a North American breeding group to manage their stock. In 2009, a pair returned to the zoo, seen in the photograph below.

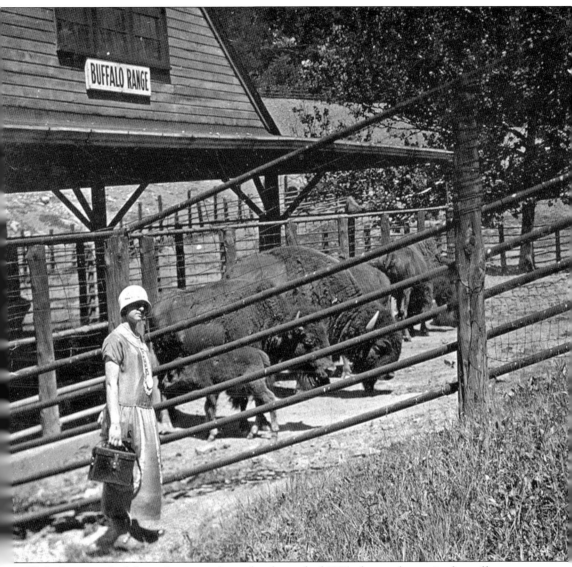

With the arrival of three American bison by the end of 1875, the zoo began its first efforts at animal conservation, one of its most successful. One of the first animals birthed in captivity was born in 1882 in Cincinnati, and in 1903, the zoo built a 3-acre exhibit for the endangered and popular animals near the site of today's Jungle Trails. By 1908, when there were fewer than 25 in Yellowstone Park, their only U.S. location in the wild, zoos had 116, including Cincinnati with the second largest herd of 12. Many specimens born in zoos were reintroduced into the wild, and by 1933, there were 4,404 in the United States. Bismark, or Bismarck, believed to be the largest bison in captivity, was purchased by the zoo, along with his mate, in 1900 for $1,100 at the Hamilton County Fairgrounds from a man traveling the country showcasing the pair. Many of the bison bred in Cincinnati were sent to Europe. This image is from 1927. (Courtesy of Cincinnati Museum Center–Cincinnati Historical Center Library.)

One of the zoo's most successful modern breeding programs of endangered species has been with the black rhino, coveted by poachers for its horns. In the 1970s, about 65,000 roamed in Kenya and Tanzania. The numbers have dropped to fewer than 3,000. In 2009, Klyde, a seven-year-old, 2,500-pound rhino, shown here, arrived from Columbus. He is the grandson of Ralph, a black rhino who died in 2002 after 30 years in Cincinnati. The first rhinoceros at the zoo was an Indian Rhino lent in 1877 by the Robinson Circus, whose winter quarters were near Cincinnati. The animal was too big to transport around the country by wagon. The visit lasted only a year when the circus began traveling by train and reclaimed their rhino.

Not one but three successful births of Sumatran rhinos, the most endangered rhino, with fewer than 200 in the wild, have taken place at the zoo, the only place in the world breeding the species successfully. The first calf, born in 2001, was the first born in captivity in 112 years and has since returned to Sumatra. Emi, shown here, who produced three calves, died on September 5, 2009.

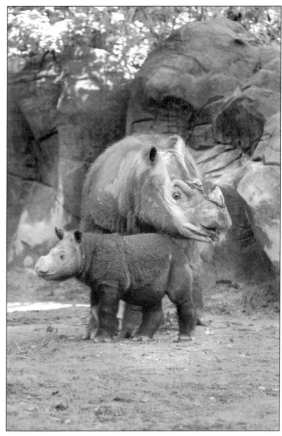

Success in breeding Sumatran rhinos did not come until the scientists at CREW at the zoo used endocrinology and ultrasonography to unlock the animal's mysterious physiology. The outcome was a testament to a combination of science, veterinary care, animal husbandry, and intensive management by the researchers, including reproductive physiologist Dr. Monica Stoops, below at right, and keeper Randy Pairan.

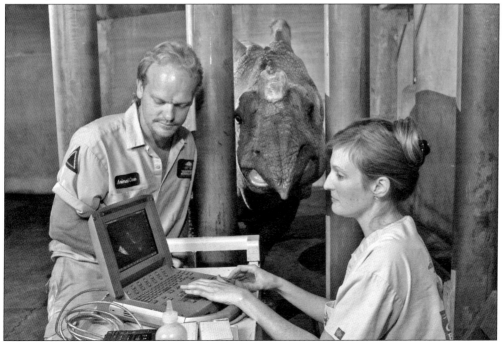

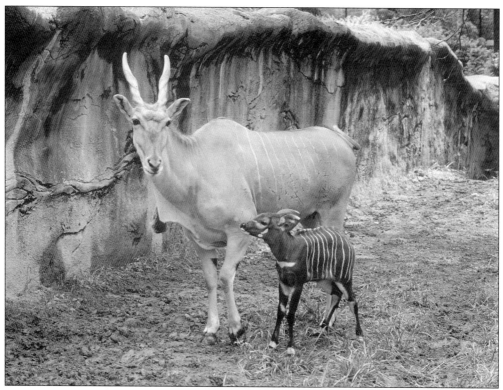

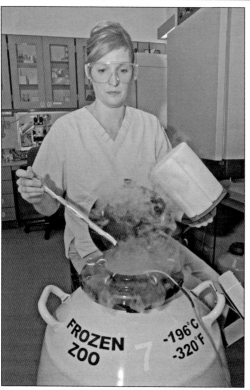

The 1980s were groundbreaking years at the zoo's CREW headquarters, as scientists worked on reproducing an endangered species by using a more common species of animal as a surrogate mother. In 1984, a rare bongo antelope was born to a surrogate eland mother, the first non-surgical interspecies transfer. In 1988, several species of endangered wildflowers were reproduced through tissue culture, and in 1989, an endangered Indian desert cat was born to a domestic cat surrogate, the first in vitro exotic cat. In the CREW "frozen zoo and garden," shown at left with staff reproduction physiologist Dr. Monica Stoops, animal sperm, eggs, and embryos, as well as plant seeds, pollen, and tissue are stored in liquid nitrogen and later thawed for reproduction.

The endangered cheetah population worldwide has shrunk from about 100,000 a decade ago to 10,000 to 12,000 today, a number that has stabilized somewhat because of work at the zoo's Mast Farm in Clermont County, one of the cornerstones for saving the endangered speedster. The off-site breeding facility, one of only four in the United States managed by the Species Survival Plan, houses cheetahs from the president of Namibia, as well as other genetically viable animals, to increase the population. Recently, three out of eight cheetah cub litters born in North America were born in Cincinnati. And in 2008, a healthy litter of cubs was born in partnership with the Columbus Zoo, including Tommy T at the zoo.

DISCOVER THOUSANDS OF LOCAL HISTORY BOOKS FEATURING MILLIONS OF VINTAGE IMAGES

Arcadia Publishing, the leading local history publisher in the United States, is committed to making history accessible and meaningful through publishing books that celebrate and preserve the heritage of America's people and places.

Find more books like this at
www.arcadiapublishing.com

Search for your hometown history, your old stomping grounds, and even your favorite sports team.

Consistent with our mission to preserve history on a local level, this book was printed in South Carolina on American-made paper and manufactured entirely in the United States. Products carrying the accredited Forest Stewardship Council (FSC) label are printed on 100 percent FSC-certified paper.

MADE IN THE USA